Aesthetics

A Beginner's Guide

ONEWORLD BEGINNER'S GUIDES combine an original, inventive, and engaging approach with expert analysis on subjects ranging from art and history to religion and politics, and everything in-between. Innovative and affordable, books in the series are perfect for anyone curious about the way the world works and the big ideas of our time.

Aesthetics
A Beginner's Guide

Charles Taliaferro

ONEWORLD

A Oneworld Book

Published by Oneworld Publications 2011
Reprinted, 2017, 2021

Copyright © Charles Taliaferro 2011

The moral right of Charles Taliaferro to be identified as the
Author of this work has been asserted by him in accordance
with the Copyright, Designs and Patents Act 1988

ISBN 978-1-85168-820-3
eISBN 978-1-78074-125-3

Typeset by Glyph International Ltd., Bangalore, India
Cover design by vaguelymemorable.com

Printed and bound in Great Britain by Clays Ltd, Elcograf S.p.A.

Oneworld Publications
10 Bloombury Street
London, WC1B 3SR
England

Stay up to date with the latest books,
special offers, and exclusive content from
Oneworld with our newsletter

Sign up on our website
oneworld-publications.com

MIX
Paper from
responsible sources
FSC® C018072
www.fsc.org

Contents

Illustrations

Acknowledgements

I am immensely grateful to the many students I have worked with in the course Aesthetics at St Olaf College and to the participants in the Art and Philosophy Reading Group. A few words about this group: in 1993 the American painter Jil Evans and I began the Art and Philosophy Reading Group in Minnesota that meets monthly for a common conversation about aesthetics, philosophy of art, art criticism, and art exhibits. This open-ended group (which still meets today) is made up of artists, curators, art critics, philosophers and anyone interested in a good-humored dialogue about art where no single person is in charge, no one dominates the conversation, and the subject of the next meeting is decided democratically. There are about a hundred people invited and, in practice, about thirty people attend each meeting. Both in the Aesthetics class and in this group, it has been a joy to practice aesthetics through provocative, engaging, sometimes absolutely exhilarating, exchanges.

In addition to thanking some specific individuals, I want to do three things in these acknowledgements: first, I recommend to all readers of this introduction to aesthetics the importance of studying and practicing aesthetics in groups. This book can be read in solitary confinement, but I suggest it will be of greater benefit if you work through its themes and recommended reading with a group of aspiring artists and philosophers. You may have picked up this book because it is a requirement for an aesthetics

class, so you are already working in aesthetics as a group. Even so, meeting with friends outside of class to *do aesthetics* has the additional merit of making aesthetics a part of your life and not just schooling. Second, I want to thank the Art and Philosophy Reading Group and my students for insightful exchanges, energy, and wisdom, much of which has impacted the writing of this book. Third, I dedicate this book in gratitude and affectionate respect both to the Art and Philosophy Reading Group and to the students who have taken Philosophy 243, Aesthetics, at St Olaf College.

I thank Mike Harpley of Oneworld Publications for inviting me to write this *Beginner's Guide*. I am deeply grateful to Tricia Little, Olivia James, Eric Erfanian, Elisabeth Granquist, Conner Westby, Therese Cotter, and Cara Stevens for advice, encouragement, and assistance in preparing this work for publication. I thank Kathleen McCully for her expert copyediting. I thank Anne Groton for her advice about New Comedy, Jonathan Hill for his guidance on poetry, and Cara Stevens for her insights on the sublime. Glenn Gordon and Matt Rohn provided invaluable editorial advice at many stages of re-writing, and I greatly acknowledge the advice of an anonymous reviewer for Oneworld. Paul Reasoner was a major contributor to reflections on Japanese aesthetics in Chapter 6. Timothy Brendler provided invaluable knowledge about classical music. I am especially grateful to Robert Entenmann and Karil Kucera for insights on Asian aesthetics, and I am grateful for helpful critical suggestions by Gary Iseminger and Vicki Harper.

Introduction
What is aesthetics?

Aesthetics refers to the philosophy of art and the philosophy of beauty. Both domains are teeming with controversial, philosophically interesting debates. In philosophy of art, there are fascinating, conflicting accounts of what is art and why works of art should be important to us. The very difference between 'art' and 'non-art' has been challenged by philosophers and artists. And the meaning and evaluation of art (or art criticism) is an ongoing, exciting area of inquiry in which there are different views of the importance of creativity, originality, imagination, ethical content (if a work of art promotes sexism or racism, is it necessarily bad art?), and whether a great work of art should stand the test of time.

Philosophical reflection on beauty has sometimes run parallel to the philosophy of art, but it brings in a broader set of issues. Today many artists do not see beauty as a principal goal and some wildly celebrated artworks seem quite ugly. For many people, judgments of beauty and ugliness seem to be entirely a matter of taste. 'Beauty is in the eye of the beholder' is now a cliché. Still, beauty remains an important topic in aesthetics, for all sorts of reasons. Historically much art has been motivated by a concern with beauty and this seems widespread culturally, involving not just the west but Africa, Asia, and the Americas. There is currently a revival of philosophical interest in beauty's role both in art today and in ethics. We will consider the reasons behind this revival in

Chapter 1 but, briefly, some philosophers might agree that beauty is in the eye of a beholder but then they propose that there are ways of beholding that are more reliable or illuminating than others. And in ethics today it is now fairly common to recognize that some moral judgments are based on aesthetics and not just, for example, science, history, intuition, and so on. The sub-title of a recent environmental ethics book is telling: *From Beauty to Duty*. Arguably, if we see something as beautiful we are more likely to protect and not exploit it.

The field of aesthetics today is thriving and the purpose of this *Beginner's Guide* is to make some of the big themes and arguments of this field available to you and to provide resources for further exploration. Let us begin in Chapter 1 with the idea of beauty.

1

What is beauty?

While today beauty may seem an entirely subjective affair, there is a substantial historical tradition linking beauty and goodness. For the fourth-century BCE philosopher Plato, for example, beauty, truth, and goodness are foundational to a life worth living. To understand the appeal of this high, holistic view of beauty one needs to appreciate the contrast in the ancient world between the love of glory and the love of beauty. Let us take a look at an ancient Greek view of beauty and then see whether it has standing today.

Beauty versus glory

In Ancient Greece, one of the great themes in literature and culture was the pursuit of glory (*kleos*). In the earliest poem we have from this time, the *Iliad*, glory is to be found on the battlefield in aristocratic violence. Noble warriors like Achilles and Hector fight to the death and the one who is victorious receives glory in the form of a mixture of praise, awesome fear, and reputation. Glory, then, had a bloody dimension and was sometimes represented by a victorious warrior displaying the bloody armour or weapon or even the body of his defeated foe. Plato was not immune to this fascination with glory. But Plato and others sought to foster a different tradition, one that centered on beauty and fecundity rather than death and violent conflict. Instead of the primacy of loving Homeric *kleos*, Plato sought to promote the loving desire for the beautiful (*kalon*). In the place

of the ideal soldier-warrior, Plato valorized the ideal, creative, ardent lover.

In the great fourth-century BCE dialogue the *Symposium*, Plato records a speech on love and beauty by the priestess and teacher of Socrates, Diotima of Mantinea. There is reason to believe Diotima was the name of an actual person as Plato seems to have rarely used names in his work that do not refer to actual people. If she was truly the source of the speech Plato records, Diotima is the most influential woman thinker in the world of ancient Greece and the history of what would come to be called aesthetics. Diotima teaches us that we should first appreciate particular beautiful things such as a specific beautiful body. We are then naturally led to love greater, more general beauties. When you love a woman or man, you come to realize that women and men are loveable or worthy of love. It is important to appreciate this is a movement or growing awareness from the particular to the general. It has been said of Don Juan, the fictional but legendary libertine, that he loved all women but loved no woman. Because he began and ended at the general level, he failed to understand what it is to love *one* woman. Diotima wants us to begin with a loving desire for a particular beauty and then ascend a ladder of loving desire until we come to what she called absolute beauty. She offers the following portrait of an initiation into the practice of loving beauty:

> Well then, she began, the candidate for this initiation cannot, if his efforts are to be rewarded, begin too early to devote him to the beauties of the body. First of all, if his teacher instructs him as he should, he will fall in love with the beauty of one individual body, so that his passion may give life to noble discourse. Next he must consider how nearly related the beauty of any one body is to the beauty of any other, when he will see that if he is to devote himself to loveliness of form it will be absurd to deny that the beauty of each and every body is the same. Having reached

this point, he must set himself to be the lover of every lovely body, and bring his passion for the one into due proportion by deeming it of little or of no importance.

We are to begin, then, in the material world, but this leads us gradually to even higher beauties. It is as though the experience of a specific individual beauty opens us up to an irresistible love of greater beauty. For those who think there is no necessity of going from the particular to the general, one might at least concede that there is some reason to do so. After all, in loving one person isn't it natural or at least reasonable to love or at least appreciate and be grateful to the people and events that helped the person grow into your beloved? A climbing of the Platonic ladder involves growing out of one beauty and traveling upwards to a greater beauty. Arguably, such an expansion or growth may be understood in terms of taking pleasure in higher goods. It appears that when you love someone or something and you take pleasure in him or it, you do seem to expand your identity. To take a trivial example, if you take great pleasure in a sports team, you might well be able to use the possessive pronoun: Manchester United (or the Yankees or the Mets) is *my* team. Many of the ancient philosophers held that it is the very nature of pleasure to expand the soul and they likewise held it as the nature of pain or suffering to contract the soul (Sorabji 2000). Perhaps when one comes to love higher beauties, there is a sense in which these higher beauties become yours by delighting in them – even to the extent of garbing yourself in a team jersey that reads 'Beckham'.

Diotima continues:

Next, he must grasp that the beauties of the body are as nothing to the beauties of the soul, so that wherever he meets with spiritual loveliness, even in the husk of an unlovely body, he will find it beautiful enough to fall in love with and to cherish – and beautiful

enough to quicken in his heart a longing for such discourse as tends toward the building of a noble nature. And from this he will be led to contemplate the beauty of laws and institutions. And when he discovers how nearly every kind of beauty is akin to every other he will conclude that the beauty of the body is not, after all, of so great moment.

The ongoing ascent then involves an emancipating, ever-expanding philosophical, beautiful awareness of the nature of reality:

And next, his attention should be diverted from institutions to the sciences, so that he may know the beauty of every kind of knowledge. And thus, by scanning beauty's wide horizon, he will be saved from a slavish and illiberal devotion to the individual loveliness of a single person, or a single institution. And, turning his eyes toward the open sea of beauty, he will find in such contemplation the seed of the most fruitful discourse and the loftiest thought, and reap a golden harvest of philosophy, until, confirmed and strengthened, he will come upon one single form of knowledge, the knowledge of the beauty I am about to speak of.

(Plato 1994, *Symposium*, 210a–e)

At the summit, the love naturally overflows with fecundity in which he or she gives birth to awesome creative productivity. The highest point of the beautiful involves a final transcendence of all images and the fulfillment of what Diotima describes as true virtue.

If someone got to see the Beautiful, absolute, pure, unmixed, not polluted by human flesh or colors or any other great nonsense of mortality … only then will it become possible for him to give birth not to images of virtue (because he's in touch with no

images), but to true virtue (because he is in touch with the true beauty).

(Plato 1994, *Symposium* 211e–212a)

This ascension to the beautiful, and thus to true virtue, as a process and consummation of true love, stands in dramatic contrast to the Homeric desire for worldly fame and domination on a battlefield. This is a heady, almost ecstatic account of a succession of loves and beauties that raise many questions we will come to shortly. But let's first clarify Plato's view of desire.

Plato (428–348 BCE) was a student of Socrates and teacher of Aristotle. He founded a school in Athens, the Academy, so named because it was in a garden named in honor of the Greek hero Academus. Much of Plato's surviving work is in the form of dialogues and reflects Socrates' recommendation that philosophy is best done in person in dialogue. Socrates thought that in dialogue one can more readily correct misunderstandings and take greater responsibility for one's arguments than in writing, though ironically we would not know this about Socrates unless Plato or someone else wrote down Socrates' opposition to writing. Throughout his work, Plato sought the *essence* of things, the essence of art and beauty, justice and truth, knowledge and the soul. Plato was opposed to Protagoras and others who promoted what Plato saw as an unacceptable relativism. In the dialogue *Protagoras*, Plato launched a major attack on relativist theories of truth (for example, what is true for one person may not be true for another). Plato thought that we should seek that which is permanently beautiful and not be bewitched by the flux and impermanence of the world. Platonic accounts of beauty had a major impact on late medieval Christianity and played into the celebration of beauty one finds in the Italian Renaissance. The fifteenth-century Florentine Academy was thoroughly Platonic in its teaching that true fulfillment can only be achieved through the love of beauty, truth, and goodness.

While Plato (perhaps inspired by Diotima) spoke of beauty itself, he also thought of beauty as the proper object of love. That which is beautiful is that which calls for or deserves our loving delight. Love, for Plato and many of the ancient Greeks, involves desire or *eros* (which may or may not involve what we would call the erotic). In the following myth or parable, love is pictured as the offspring of *poros* (the personification of plenty) and *penia* (the personification of poverty):

> So because Eros is the son of Poros and Penia, his situation is in some such case as this. First of all, he is always poor; and he is far from being tender and beautiful, as the many believe, but is tough, squalid, shoeless, and homeless, always lying on the ground without a blanket or a bed, sleeping in doorways and along waysides in the open air; he has the nature of his mother, always dwelling with neediness. But in accordance with his father he plots to trap the beautiful and the good, and is courageous, stout, and keen, a skilled hunter, always weaving devices, desirous of practical wisdom and inventive, philosophizing through all his life, a skilled magician, druggist, sophist.
>
> (Plato 1989, 203c–d)

Eros, then, is full of energy and stealth, and even inclined to philosophy (the love of wisdom) while also feeling need and a keen lack of satiation or fulfillment. There is a sense in which a person who desires is always seeking what the person lacks. If you are strong now, it makes no sense (from a Platonic point of view) for you to desire strength. It is because we lack beauty that we seek it. And in so doing, we take the first step in the direction of the beautiful itself. It is a deeply Platonic thesis that has been defended down to our own day, that if something is good, it is good to love it. There is a sense, then, that if you love beauty, your love in some sense is itself beautiful. If, for example, justice is both good

and beautiful, it seems that loving justice would be both good and beautiful. We may imagine cases when someone may claim to love justice and do nothing to promote justice, but in cases where there is power and authenticity it appears that a lover of justice would naturally be one who would honor justice in her or his life and action. Platonists through the centuries have endorsed similar notions with respect to the virtues: to love wisdom is itself wise. As Plato suggests at the beginning of his masterpiece *The Republic*, the love of the good and the beautiful is an inherently youthful enterprise: it is not for those who are content with the loss of desire in old age, but for those at any age who are filled with a restless desire or *eros* for the good.

The legacy of Platonic beauty

The Platonic philosophy of beauty has an important legacy from the ancient world through the medieval ages and early modern philosophy. It is often linked with works of art that represent the idealized beautiful body (as in Figure 1). Art that fosters the loving attention on a beautiful body can be seen as art that beckons us to get to the first rung on the ladder of love.

There is a natural sense in which when you love something, you are committed or at least inclined to think that objects resembling what you love are also worthy of love. It would be at least peculiar to love one woman and then not to believe that other women are worthy of love or loveable. It is difficult to imagine loving only a single object and not also loving its properties, properties that can be exemplified by others. Even if love of one person does not in fact lead you to love anyone or thing that resembles them, love of one person at least opens one up to understand the loveableness of others. It may be protested that human psychology is the reverse of Plato's claim: we tend to move from the general (they are a nice bunch of people) to

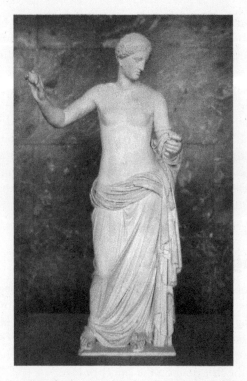

Figure 1 *Aphrodite of Arles*, associated with Praxiteles (c.375–c.340 BCE), marble, Musée du Louvre (photo: Sting/Wikimedia Commons).

the particular (I love her or him). But there is evidence on the other side. For example, one of the reasons why most of us have heard of Confucius and few have heard of Mozi (two roughly contemporary Chinese thinkers) is because Confucius focused on specific relations and persons, whereas Mozi emphasized universal (general) love. There are many reasons for Confucius' success in comparison with Mozi, but part of the difficulty with Moism is that its beautiful teaching was too abstract and not anchored in

the particular and concrete. Or consider the concept of brotherly and sisterly love. Arguably, this general concept would not have any hold on us unless we have some acquaintance with concrete good cases of sibling relations. Once one grasps the goodness of the particular, however, one can then readily move to the more general.

A look at beauty in other historical, cultural contexts offers some support for the Platonic notion of beauty and goodness. Plato and Diotima would resonate with the Hindu stress on the good, the true, and the beautiful. There is a familiar Hindu expression that describes God as Satyan (truth), Shivam (goodness) and Sundaram (beauty). Beauty, or Sundaram, coincides with the highest good and so there could not be something that was thoroughly beautiful and not good. African aesthetics also offers some support for a Platonic view of beauty and goodness. In Yoruba discourse, for example, *ewa* (the term most frequently translated as 'beauty') is directly linked with goodness. The Yoruba make a distinction between outward *ewa* and inward *ewa*. Outward *ewa* concerns physical appearance and behavior, whereas inner *ewa* is thought of as moral beauty. As Stephen David Ross observes, there is a widespread historical testimony to the link between beauty and goodness in many cultures. Ross offers this overview:

In the earliest cultures known, before written history, and in China, Egypt, the Islamic world, and sub-Saharan Africa, beauty was and still is a term of great esteem linking human beings and nature with artistic practices and works. Human beings – men and women – their bodies, characters, behaviors, and virtues are described as beautiful, together with artifacts, performances, and skills, and with natural creatures and things: animals, trees, and rock formations. In such cultures beauty, goodness, and truth are customarily related. Ancient Greece and China were no exceptions. In the Confucian tradition, Kongzi (sixth to fifth

century BCE) emphasized social beauty, realized in art and other human activities. Two centuries later, Daoism united art and beauty with natural regularity and purpose, and with human freedom.

(Ross 1998, 237)

The Platonic link between beauty and goodness may seem deeply attractive in terms of value theory. In modern times, we perhaps often think that a villain is attractive or alluring, but this may be due to only a partial realization of the object in question. So, you might admire or find Satan fascinating in Milton's *Paradise Lost*, but then there might be two things going on. What you admire truly is admirable. Imagine it is Satan's defiance and independence that you admire. Such attributes may well indeed be valuable and beautiful. But then when you take seriously what Satan does in the poem it is hard to sustain the positive judgment. Sin emerges from Satan's head in the form of a woman whom he then rapes. The child that is borne to Sin is called Death who then rapes its mother. When the details are worked out, there is no beauty here: taken on the whole, Milton's Satan is pretty ugly. Consider an analogy. Imagine you observe an atomic explosion over a city. You see a huge mushroom cloud climb nine miles in the air. The cloud seems to you sensuous and billowy. Is this a major conflict that unsettles the Platonic account? Perhaps not, for you can see that the shape is indeed beautiful, but the incendiary death of thousands or millions of people is profoundly ugly. This is not a case, then, of when the same object in the same respect is both bad and beautiful or good. The claim is not that Plato is clearly right here about beauty and goodness, but it remains the case that a Platonist has a defensive strategy against some possible objections. If you have reason to believe something is genuinely beautiful and yet morally base, you have a reason to challenge Plato. But keep in mind that a proper counter-example must be a case when the very same thing in the same respect would have to be beautiful

and ethically wrong (for example, a beautiful looking serial killer would not, for example, do the trick).

Challenging Platonic beauty

The Platonic tradition in aesthetics has been challenged on many fronts. A helpful way to further explore the resources as well as vulnerability of Platonic aesthetics is to consider the Platonic vision of beauty in light of several objections.

One problem may be that a Platonic view of beauty and goodness can support a very negative view of important works of art. Plato's link between the beautiful and the good led him to question the good of works of art that depict evil. As we will come to further explore in the next chapter, many of the ancients saw artworks as imitations (mimesis) of the events they depict. When you depict the Trojan War in a play, you wind up imitating the Trojan War. This has some warrant. After all, if you did not *imitate* the war but *undertook an actual war*, you would not really be engaged in theater. Artworks have to have *some* removal from the scene that they are portraying. The actual Trojan War (assuming for the moment that it actually took place) could not itself be a play. On this imitation view, it seems that if something is good, the imitation of it is or can be good, but the converse is also plausible: if something is evil, then the imitation of it is evil. This thesis laid the groundwork for a Platonic critique of tragedy, including a critique of Homeric poetry with its celebration of violent glory.

We may be highly reluctant to follow Plato in his critique of tragedy but at the outset his thesis has some plausibility. Imagine that it is bad for a mother to believe her son is a lion and then, in a frenzy, tear him limb from limb and carry his head back to her city as a trophy. If this is bad, isn't it bad to imitate? But this is precisely what the fifth-century BCE dramatist Euripides

stages in his tragedy *The Bacchae* in which Agave is induced by Dionysus to dismember her son, Pentheus. Assuming it is wrong for a woman to poison her husband's mistress (whom he intends to marry) and kill her own children, doesn't it seem at least not good when, in the play *Medea*, the character Medea murders her rival and kills her own children? If theater consisted of no more than the imitation of evil, wouldn't we find this deeply problematic, perhaps revealing a form of sadism or a desire to revel in that which is repugnant to non-violent personal and civic life? So, the first problem with a Platonic view of beauty may not be decisive.

Another and perhaps deeper problem with Platonic aesthetics involves the very notion of the beautiful or beauty as an ideal form and the thesis that the beautiful things we observe are beautiful because they participate in or exemplify this form. While a general Platonic view of ideals and abstract objects may be defensible, much can be salvaged from Platonic aesthetics if we bracket the idea of an ideal form as well as the idea that objects have beauty in the sense that beauty is an objective property like size and shape. This one difficulty does not seem very deep. For those who have trouble anchoring beauty as a feature of an object itself, one may have recourse to referring to beauty *as the normative relationship of that which ought to give rise to aesthetic delight*. To remain Platonic this relationship needs to be seen as something that *ought* to occur. So, just as the following would not do as the definition of being funny:

X is funny if X causes an observer to laugh

the following would not do for beauty:

Y is beautiful if Y causes an observer aesthetic delight

The first definition does not work because it would mean nitrous oxide would be funny for, after all, it makes one laugh.

The addition that is needed is that X is funny if it *ought* to give rise to laughter, and similarly beauty involves fitting aesthetic delight. Y is beautiful if it ought to cause observers to have aesthetic delight in it. W. D. Ross adopts such a normative view of beauty:

> The view to which I find myself driven, in the attempt to avoid the difficulties that beset both a purely objective and a purely subjective view, is one which identifies beauty with the *power* of producing a certain sort of experience which we are familiar with under such names as aesthetic enjoyment or aesthetic thrill.

> (Ross 1930, 127)

Beauty, then, may be plausibly characterized in terms of that which stimulates aesthetic delight or thrill. 'Beauty', then, names a proper relationship involving our senses.

Aristotle (who was Plato's student for twenty years) seemed inclined to see beauty in terms of perceptual relations. His specific reflections about perceiving beauty emphasize the framework of observation:

> Beauty is a matter of size and order, and therefore impossible either in a very minute creature, since our perception becomes indistinct as it approaches instantaneity; or in a creature of vast size — one, say, 1,000 miles long — as in that case, instead of the object being seen all at once, the unity and wholeness of it is lost to the beholder. Just in the same way, then, as a beautiful whole made up of parts, or a beautiful living creature, must be of some size, but a size to be taken in by the eye, so a story or plot must be of some length, but of a length to be taken in by the memory. As for the limit of its length, so far as that is relative to public performances and spectators, it does not fall within the theory of poetry. If they had to perform a hundred tragedies,

they would be timed by water-clocks, as they are said to have been at one period. The limit, however, set by the actual nature of the thing is this: the longer the story, consistently with its being comprehensible as a whole, the finer it is by reason of its magnitude.

(Aristotle 1984, 1450b37–1451a11)

So, for Aristotle, rather than the beautiful being an abstract form, beauty seems definable in light of proper beholding and in relation to the observer's memory, vision, and other cognitive powers.

Another difficulty involves the Platonic ladder. When you love another person, do you love her properties or the person herself? This question may not matter, but under some circumstances this question seems quite serious. Imagine you are attracted to a person because of her beauty based on her humor, intelligence, and elegance. You even come to love her. But imagine one day she loses her humor, intelligence, and elegance. What happens to the love? From a Platonic point of view, it seems that the object of love has disappeared. Or, imagine she retains her qualities, but you meet someone with even greater beauty in terms of her humor, intelligence at the level of genius, and an elegance that positively sends you into rapture. Again, the Platonist seems not able to fully account for why you might still love and be faithful to your beloved, no matter how the properties fall out or are out matched.

There may be a way around this problem. Arguably, persons are not bundles of properties, but we are subjects with properties or, as it were, propertied subjects. This may allow for anchoring one's attention on the individual. Perhaps a single person, Beatrice, might be the locus of your first encounter with beauty and it is due to this history and her particular configuration of beauty that you remain loyal to her no matter what other beauties are exemplified. In Diotima's speech, the higher we climb the ladder of love, we come to look back at the foundational,

initiatory beauties as 'of little or of no importance'. But is this necessary? Platonists in the Christian tradition stressed the vital importance of loving both heavenly and earthly goods. This was the theory of love that is at work in Dante's fourteenth-century masterpiece *The Divine Comedy* in which he celebrates his ardent love of Beatrice (a particular person) and yet he also loves her as a portal or mediator of divine love. The loving of higher goods can even enhance or magnify our valuing of temporal, passing goods. (This altered form of Platonism would, however, have to employ a metaphor or image other than a ladder that one climbs, because with most ladders you leave the lower rungs behind you as you ascend! Perhaps this alternative Platonic model might be pictured as a fountain or spring of love.)

Two more difficulties need to be faced: Plato claims that goodness creates the ground of love, but some philosophers have claimed that love itself can provide its own reasons for valuing objects. Second, philosophers have worried about how to objectively find out what is beautiful. We seem to find a great variety of different, incompatible examples of beauty over time. And in the midst of such variation, we may wind up with experiences that seem to cut against the Platonic thesis that goodness and beauty are always together.

The objection that love can generate its own reasons has been advanced by Harry Frankfurt. In the following passage, Frankfurt first depicts the Platonic-Diotima position in which love responds to goodness, and then he proposes that love itself can create its own reason to care for something or, in Frankfurt's case, to care for his children:

> Love is often understood as being, most basically, a response to the perceived worth of the beloved. We are moved to love something, on this account, by an appreciation of what we take to be its exceptional inherent value. The appeal of that value is what captivates us and turns us into lovers. We begin loving the

things that we love because we are struck by their value, and we continue to love them for the sake of their value. If we did not find the beloved valuable, we should not love it.

This may well fit certain cases of what would commonly be identified as love. However, the sort of phenomenon that I have in mind when referring here to love is essentially something else. As I am construing it, love is not necessarily a response grounded in awareness of the inherent value of its object. It may sometimes arise like that, but it need not do so . . .

It is not necessarily as a *result* of recognizing their value and of being captivated by it that we love things. Rather, what we love necessarily *acquires* value for us *because* we love it. The lover does invariably and necessarily perceive the beloved as valuable, but the value he sees it to possess is a value that derives from and that depends upon his love.

Consider the love of parents for their children. I can declare with unequivocal confidence that I do not love my children because I am aware of some value that inheres in them independent of my love for them. The fact is that I loved them even before they were born – before I had any especially relevant information about their personal characteristics or their particular merits and virtues. Furthermore, I do not believe that the valuable qualities they do happen to possess strictly in their own rights would really provide me with a very compelling basis for regarding them as having greater worth than many other possible objects of love that in fact I love much less. It is quite clear to me that I do not love them more than other children because I believe they are better.

(Frankfurt 2004, 38–9)

If Frankfurt is right, loving another person can be the source of great value. You may think your children or brothers are great, but this is because you love them, rather than because you have come to see them as valuable.

Frankfurt offers an extensive further point about the parent–child relationship:

> It is not because I have noticed their value, then, that I love my children as I do. Of course I do perceive them to have value; so far as I am concerned, indeed, their value is beyond measure. That, however, is not the basis of my love. It is really the other way around. The particular value that I attribute to my children is not inherent in them but depends upon my love for them. The reason they are so precious to me is simply that I love them so much. As for why it is that human beings do tend generally to love their children, the explanation presumably lies in the evolutionary pressure of natural selection. In any case, it is plainly *on account of* my love for them that they have acquired in my eyes a value that otherwise they would not certainly possess.
>
> (Frankfurt 2004, 40)

If Frankfurt is right, the Platonic understanding of love and beauty seems mistaken or it leaves out the power of love itself. How might Diotima or Plato reply?

Part of Frankfurt's philosophy of love makes sense. It would be odd if parents based their love for their children on the belief that theirs are the most beautiful children they have seen. Even so, Frankfurt does not seem to appreciate the good or beauty that accounts for his love: *the good of patrimony* or, more broadly, *the good of parentage*. Arguably, it is good and beautiful to give birth to and raise children. That is a good to be loved and prized, rather than something that becomes good only when it is loved. More importantly, it would be odd to think one's children's value stemmed from the love of parents. This would entail that if the parents were damaged and not able to love, the children would have no value (at least no value to the parents). But it seems to make perfect sense to claim that in such unfortunate

circumstances, the children are still of great value and should be loved by the parents when they recover.

The second and final difficulty to face in this chapter, and perhaps the most important, lies in the apparent fluctuation of our aesthetic judgments, the variation of what it is that we find beautiful. The eighteenth-century Scottish philosopher David Hume is the figure who most famously seemed to lay the groundwork for the notion that beauty is in the eye of the beholder:

> A thousand different sentiments, excited by the same object, are all right because no sentiment represents what is really in the object ... beauty is no quality of things themselves; it exists merely in the mind which contemplates them; and each mind perceives a different beauty. One person may even perceive deformity where another is sensible of beauty and every individual ought to acquiesce in his own sentiment without pretending to regulate those of others.
>
> (Hume 1965, 268)

Hume did not, however, hold that *anything* goes in terms of beauty, aesthetics, and judging art. Beauty may be in the eye of the beholder, but it is important that the beholder actually sees and experiences the art or natural object (a candidate to be judged beautiful). Sometimes misinformation, faulty sensory organs, prejudice, egotism (you like painting x because you painted it), lack of emotional maturity, and so on, can obscure and utterly undermine aesthetic judgment. Hume himself seemed to think that there would (or should?) arise some convergence on recognizing what we judge to be beautiful and excellent in art:

> Whoever would assert an equality of genius between Ogilby and Milton, or Bunyan and Addison, would be thought to defend no

less an extravagance than if he had maintained a mole-hill to be as high as Tenerife or a pond as extensive as the ocean. Though there may be found persons who give preference to the former authors, no one pays attention to such a taste and we pronounce, without scruple, the sentiment of these pretended critics to be absurd and ridiculous.

(Hume 1965, 230–1)

David Hume (1711–76) was a Scottish philosopher who made substantial contributions to almost every area of philosophy, as well as authoring a masterful four-volume history of England. Hume is especially well known for his empiricism (from the Greek *empeiria*, meaning 'experienced in' or 'acquainted with') which took sensory experience as our most important and reliable means of knowledge. He opposed the Platonic ideal of permanent beauty which the soul should ascend to; he held instead that matters of beauty and ugliness were reflections of individual taste and temperament. But in aesthetics and ethics, he did not think 'there are no standards at all' and he sought to identify proper ways of judging excellence in art and ethical virtues. Hume's work prompted his friend Adam Smith (1723–90) to develop an account of goodness in terms of the judgment of an ideal, impartial spectator or observer; what is good or ill is what would be approved of or disapproved of by an ideal observer. Such an ideal observer theory does not assume there actually is an ideal observer, but it sketches ideals to strive for.

Some philosophers have extrapolated from Hume an ideal aesthetic observer theory, according to which an ideal observer of some state of affairs (this could be a work of art or a natural object) would be one that was impartial, knows all facts about the state of affairs, and affectively grasps all its emotive features. From that vantage point, the state of affairs is beautiful if it gives rise to aesthetic delight in the ideal observer, whereas it is ugly if it gives rise to displeasure (or disgust) (Taliaferro 1990). If this

account is right, there need not be an actual ideal observer. Still, the notion of an ideal observer may be implicit in our practice of arguing about the beauty of states of affairs. If we disagree about whether, for example, Vincent Van Gogh's painting *Starry Night* is beautiful, aren't we each going to seek out an impartial point of view and urge each other to look at Van Gogh's rendering of swirling clouds, stars, the luminous night sky, and so on?

An ideal observer analysis of beauty may well identify necessary conditions for aesthetic observation, but what is missing is the Platonic, normative authority involved in beauty: that which is beautiful *ought to be an object of pleasure or delight in a fair-minded observer*. Still, even if we settle for Hume and an ideal observer theory, we might secure a couple of rungs up Diotima's and Plato's ladder. We would not be approaching pure beauty, but we would not be left without any guidance in apprehending a host of beauties with aesthetic pleasure. We should seek to approach beauty with impartiality, as opposed to bias and vanity, an awareness of the object itself (instead of a mistaken perception), and an appreciation of the object's affective properties.

The Platonic heritage made a comeback in the late twentieth century. One of the leading figures to spearhead a Platonic revival is Iris Murdoch. In *The Sovereignty of Good*, Murdoch writes movingly about the curative, emancipatory character of beauty:

> Beauty is the convenient and traditional name of something which art and nature share, and which gives a fairly clear sense to the idea of quality of experience amid changes of consciousness. I am looking out of my window in an anxious and resentful state of mind, oblivious of my surroundings, brooding perhaps on some damage done to my prestige. Then suddenly I observe a hovering kestrel. In a moment everything is altered. The brooding self with its hurt vanity has disappeared. There is nothing now but kestrel.
>
> (Murdoch 2007, 82)

Notice how Murdoch finds in the love of beauty a cure for the self-preoccupied seeking of reputation and personal glory. This recalls the origin of the love of beauty in the west with its contrast to the more violent passion for glory and fame.

In bringing the opening exploration of beauty in Chapter 1 to a close, consider Murdoch's Diotima-Platonic vision of love and the good which stands in sharp contrast to Frankfurt's account of love and the value he places on his children. Although she does not explicitly refer to beauty in what follows, Murdoch describes below what she takes to be the heart of beauty: love of the good.

I think that Good and Love should not be identified, and not only because human love is usually self-assertive. The concepts, even when the idea of love is purified, still play different roles. We are dealing here with very difficult metaphors. Good is the magnetic centre towards which love naturally moves. False love moves to false good. False love embraces false death. When true good is loved, even impurely or by accident, the quality of the love is automatically refined, and when the soul is turned towards Good the highest part of the soul is enlivened. Love is the tension between the imperfect soul and the magnetic perfection which is conceived of as lying beyond it. (In the *Symposium* Plato pictures Love as being poor and needy.) And when we try perfectly to love what is imperfect our love goes to its object *via* the Good to be thus purified and made unselfish and just. The mother loving the retarded child or loving the tiresome elderly relation. Love is the general name of the quality of attachment and it is capable of infinite degradation and is the source of our greatest errors; but when it is even partially refined it is the energy and passion of the soul in its search for Good, the force that joins us to Good and joins us to the world through Good. Its existence is the unmistakable sign that we are spiritual creatures, attracted by excellence and made

for the Good. It is a reflection of the warmth and light of
the sun.

(Murdoch 2007, 100)

Iris Murdoch (1919–99) was a leading British philosopher and
novelist who advocated Platonic aesthetics and values. Her novels
such as *The Good Apprentice* weave together narrative drama
and explicit philosophical reflection on goodness and beauty.
She believed that the objective reality of goodness is evident
in everyday experience. By her lights, the experience of beauty
can free us from self-preoccupation and help fix our minds on
the good of others and the natural world. Although she was an
atheist, goodness itself came to play a role akin to God in Christian
theism (we owe our fidelity to goodness which merits a reverence
bordering on worship). 'The sovereign Good is ... something which
we all experience as a creative force' (Murdoch 1992, 507). Like
Diotima and Plato, Murdoch held that our experience of beauty
and goodness prompts us to fruitful, imaginative creativity. This
represents an ideal account of the person that fulfills the best
thinking we can achieve. 'It may be that the best model for all
thought is the creative imagination' (Murdoch 1992, 169).

In Murdoch's valorization of beauty in our own days, we have
returned to the font of Platonic aesthetics. Her work suggests
that the final case for beauty must rest on experience. In our
experience of the beautiful and the good, do we apprehend that
which truly does demand our rapturous, loving desire?

I end this chapter by citing one of the leading advocates of
beauty (along with Iris Murdoch) in the Platonic tradition, Guy
Sircello. In this passage, Sircello makes a bold claim about the
importance of beauty:

Beauty is the best and most delightful part of our world, and in
loving the best of the beautiful, we are the happiest and best of

creatures. Without the love of even the slightest kind of beauty, we are less happy and less good than we otherwise might be, and of nothing other than beauty can this be said. Loving beauty is therefore of the utmost importance.

(Sircello 1989, 210)

Perhaps Sircello and the Platonic tradition need to be abandoned, but even the possibility of it being true and illuminating makes it worthy of an ongoing re-examination. Let us now turn to consider the nature of works of art.

2
What is a work of art?

Today the word 'art' is used in a way so that someone may rightly claim to point to an object on a wall and refer to it as 'art'. In fact, in the wide-open, wild west discourse on art today it seems that almost anything can be called 'art'. We have moved decisively beyond the canon of classical art objects such as the *Mona Lisa* or the *Pietà*. In 1917 Marcel Duchamp famously put on exhibit a urinal entitled *Fountain*. In 1994 Chinese artist Zhang Huan lathered his body in fish oil and honey and then exposed himself to insects and flies; the performance is called *12 Square Meters*. In 1992 Damien Hirst put on exhibit the body of a dead tiger shark in formaldehyde; the piece is titled *The Physical Impossibility of Death in the Mind of Someone Living*. In 2000 Marco Evaristti put on display blenders full of goldfish which viewers were invited to turn on. The piece is entitled *Helena: The Goldfish Blender*. Can simply calling something 'art' make it art?

Our current relationship with art seems far different from that of ancient Greece up until (roughly) the early twentieth century. For the ancients, 'art' as a term would be a way of referring to a 'work of art', the product or result of art. The root Latin term is *ars*, and in Greek it is *techne*; 'art' refers to a principled way of producing artifacts. In the ancient world, if one were going to point to *ars* or art you would point to someone making things in a principled manner like a carpenter. *Poesis* (from which we get 'poetry') was the term used to refer to the creating or making of objects, including works of art. The thesis that a work of art or

(simply) art is artifactual is one of the most enduring tenets in the history of the philosophy of art. Is it sustainable today?

Let us first consider the ancient concept of art, and then examine some of the major accounts of what makes an object a work of art.

Making works of art in the ancient world

What did Plato think a work of art is and why? Plato recognized many practices as arts – shipbuilding, carpentry, chariots – as these possess a *techne* or technique. Art, for Plato and others in the ancient world, was seen as a technical practice involving principles. Plato questioned whether poetry possesses any *techne* that would link the poet to the good. By his lights, the poet does not even grasp her or his own practice, but is, rather, like someone possessed by a spirit and lacking in self-understanding and self-control. In the dialogue *Ion*, Plato offers this portrait:

> For of course poets tell us that they gather songs at honey-flowing springs, from glades and gardens of the Muses, and that they bear songs to us as bees carry honey, flying like bees. And what they say is true. For a poet is an airy thing, winged and holy, and he is not able to make poetry until he becomes inspired and goes out of his mind and his intellect is no longer in him.
>
> (Plato 1983, 534a–b, 10)

Poets inspire each other as they form a kind of conductor, passing on inspired energy. Plato explains the nature of contagious inspiration to the poet Ion:

> One poet is attached to one muse, another to another (we say he is 'possessed', and that's near enough, for he is *held*). From these

first rings, from the poets, *they* are attached in their turn and inspired, some from one poet, some from another: some from Orpheus, some from Musaeus, and many are possessed and held from Homer. You are one of *them*, Ion, and you are possessed from Homer. And when anyone sings the work of another poet, you're asleep and you're lost about what to say; but when any song of that poet is sounded, you are immediately awake, your soul is dancing, and you have plenty to say. You see it's not because you're a master of knowledge about Homer that you can say what you say, but because of a divine gift, because you are possessed.

(Plato 1983, 536b–c)

The link between inspiration and being divinely possessed is preserved in the etymology of the English term 'enthusiasm' which comes from the Greek word for being possessed by a god (*enthousiasmos*). Plato's concept of poetic inspiration was perhaps influenced by the way the ancient poets invoked muses (inspiring goddesses) to assist them (as in the opening lines of the *Iliad* and *Odyssey*). Plato reasoned that poets qua poets do not seem to have a *techne* in the way a shipbuilder does. He thought that if you want to know about shipbuilding, you should go to a shipbuilder; if chariots, go to a maker of chariots. But why expect a poet who writes of ships and chariots to know about these? A warrior would seem to be a better resource if you wish to know about war, rather than poets.

Plato may have a point, but what he is missing is that so many of the ancient poets had first-hand experience of chariots and ships and war and the many themes in the Greek tragedies. So, Aeschylus fought in the Battle of Salamis (Euripides is believed to have been born on the day of victory) and Sophocles was selected to participate in celebrations of the victory. Euripides would have been well acquainted with the Battle of Melos, one of the more notorious battles of the whole Peloponnesian War.

In 415 BCE, the Athenians assaulted Melos and, when the Melians surrendered, the Athenians killed all males who could bear arms, and enslaved all the women and children. Euripides' play *The Trojan Women*, a tragedy composed in the same year as the battle, may be read as a critique of the Athenian treatment of the Melians. In brief, the tragic poets were not unfamiliar with their subjects. Similarly, today, poets, novelists, and artists of all kinds are rarely immune to experiential acquaintance with their subject matter.

As testimony to the authenticity of the ancient and modern poetic treatments of war, one may take note of how modern soldiers have been able to resonate with Homeric poetry. Consider this extraordinary Homeric portrait of the warrior Achilles who was outraged at the killing of his beloved friend Patroclus:

> No, these lips shall not taste one morsel of food, nor of wine drink, While my companion and friend, cut down by the spear of the foeman, Lies at the door of my tent with his comrades lamenting around him. Truly for such things care I have none in my soul, but I think of Slaughter and carnage and gore, and the death-pang groanings of heroes.
>
> (Homer 1867, Book XIX, ll. 195–9)

This mixture of anger and grief resonated fully with poet and soldier Patrick Shaw-Stewart (1888–1917) who wrote 'Achilles in the Trenches' of the awful 1915 battle at Gallipoli:

> I saw a man this morning
> Who did not wish to die;
> I ask, and cannot answer,
> If otherwise wish I.
> Fair broke the day this morning
> Upon the Dardanelles:

The breeze blew soft, the morn's cheeks
Were cold as cold sea-shells.
But other shells are waiting
Across the Aegean Sea;
Shrapnel and high explosives,
Shells and hells for me.
Oh Hell of ships and cities,
Hell of men like me,
Fatal second Helen,
Why must I follow thee?
Achilles came to Troyland
And I to Chersonese;
He turned from wrath to battle,
And I from three days' peace.
Was it so hard, Achilles,
So very hard to die?
Thou knowest, and I know not;
So much the happier am I.
I will go back this morning
From Imbros o'er the sea.
Stand in the trench, Achilles,
Flame-capped, and shout for me.

(Shaw-Stewart, cited in Knox 1920, 159–60)

Arguably, poets and other artists have their own aesthetic sensibility that may enable them to see what we neglect. Dostoevsky was not a psychologist, but he may have understood the unconscious long before Freud. Insofar as artists in general or poets in particular cultivate their affective observation – the ability to grasp emotive or affective properties – perhaps they are better enabled to convey the terror of battle, the brooding multiple layers of self-awareness, and so on.

Plato was not just critical of poetry, but he also had critical reservations about representational art, painting especially.

To understand his critique you have to be willing to entertain that there are ideal forms such as the form *tree*, *bed*, *table*, and so on for all types of things, and that particular, concrete cases of trees and beds are appearances or reflections of these ideal forms. The painter who then paints a representation of particular trees and beds is thereby making an appearance of an appearance. The artist is then twice removed from the ideal form. Plato seems to castigate painters and other representational artists as somehow only dealing with shadows of shadows. How might this critique be answered? One short and easy response would simply be to deny that there is some ideal realm of forms. Maybe talk of an ideal circle or some other geometrical shapes makes sense, but could there be an ideal bed? The very idea seems absurd. But for the sake of argument, let's allow that there might be ideal forms.

The Platonic thesis that artists merely work with imitations and appearances may seem quite deflationary, but there are some ameliatory considerations. For the ancients, 'imitation' (mimesis) was broadly construed and can be understood more generally as artists making representations or interpretations of objects and not merely copies. Also, for Plato and especially Aristotle, imitation was understood to be key to education. (Plato's dialogues may be read as part of the goal to encourage us all to imitate Socrates.) And whatever disparagement of sensory experiences Plato fostered may be seen as having a positive effect. This latter point is worth pausing over.

Partly because Plato distrusted sensory experience, he was less prone to trust his empirical observations of the status quo and conclude that women were, by nature, subordinate in all matters to men. Aristotle, who observed the marginalization of women from power, thought this was natural, whereas Plato thought that there is no natural obstacle preventing women from being great rulers. It might also be noted that some modern painters may be seen in the Platonic tradition insofar as they

seek to represent ideal forms. Arguably, some formalist art is in the Platonic tradition, with its stress on nonrepresentational formal abstract shapes and colors. Consider, for example the work of Piet Mondrian, which features lines and squares in differing colors. Plato's thesis that beyond appearances one may conceive of ideal forms has had some artistic role quite apart from Plato's disparagement of art as representations.

The idea that works of art are mimetic has a rich history through the Renaissance. Giorgio Vasari summarizes a popular sixteenth-century position: 'Painting is simply the imitation of all the living things of nature with their colours and designs just as they are in nature' (Vasari 1978, 46). Figure 2, a bronze sculpture of Zeus or Poseidon, would have been seen as a prime example of mimetic art, a statue that imitates how a god appears.

The mimetic tradition, however, faced difficulties. It did not seem to speak to the fact that artists do not simply seek to copy or re-enact or make a likeness of their subject matter. Artists seek to idealize or critique their subjects or invent subjects that seem to go beyond mere imitation. Imitation also seems to involve resemblances, but it becomes problematic in identifying what sorts of resemblances may be involved. Does a two-dimensional portrait painting on canvas in a frame really resemble its object? Arguably, we pick out what counts as a relevant resemblance (a portrait might give you an idea of how Queen Victoria looked shortly after her coronation) due to learned conventions. Some mid-twentieth-century aestheticians turned decisively against the resemblance-imitation theory on the grounds that works of art involve reference, as in linguistic denotation. On this view, works of art function more like different linguistic statements that reference objects, rather than mirrors that offer us a reflection of what we might otherwise see directly without the aid of a mirror. Nelson Goodman, for example, likened pictorial representation to a language you must learn. Just seeing a painting of Queen Victoria and Prince Albert would be no more helpful in grasping

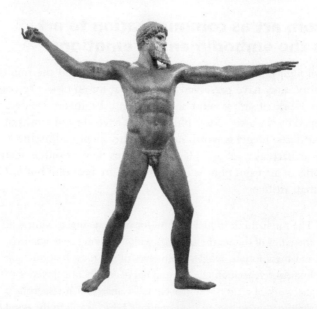

Figure 2 *Poseidon of Artemision* (c.460–450 BCE), bronze, National Archaeological Museum (Greece). This is a disputed attribution; some think this may be a statue of Zeus (photo: Marsyas/Wikimedia Commons).

its subject matter than hearing the sentence 'Queen Victoria was married to Prince Albert', unless you understood English. And of course a statement about Queen Victoria does not resemble the queen. Goodman proposed that seeing what we take to be resemblances is a complex, learned practice. We learn to see similarities, if Goodman is right, just as we learn language.

The idea that art is mimetic has its defenders. Indeed, some claim that a portrait of Queen Victoria does in some way resemble the way she would have looked at the time of the painting. But because this mimetic model for what is a work of art did not seem to get at the affective and expressive nature of art-making, new models were advanced historically.

From art as communication to art as the embodiment of emotions

Although philosophers of art have moved beyond the mimetic theory, they have preserved the idea that for an object to count as a work of art, it must in some sense be made, created, or shaped by the artist. Most philosophers have viewed works of art as artifacts. Hegel is worth noting for his adept endorsements of the artifactuality of art. Hegel offers this way of differentiating works of art from objects in nature that are beautiful but not by human artifice:

> The torch-thistle, which blooms for only one night, withers in the wilds of the southern forests without having been admired, and these forests, jungles themselves of the most beautiful and luxuriant vegetation ... rot and decay equally unenjoyed. But the work of art is not so naively self-centered; it is essentially a question, an address to the responsive breast, a call to the mind and spirit.
>
> (Hegel 1975, 71)

On Hegel's view, works of art are distinctive because they involve mind or spirit. A work of art can raise questions or can be made up of a question; for example, Picasso's *Guernica* raises a question (and protest) about fascist military action. Natural objects can be the object of questions, but they have no meaning or aboutness supplied by mind. So, a storm may prompt us to question the best way to avoid a shipwreck, but it is we (and not the storm) who are raising the question.

Granting the artifactuality of art and the realization that more is at stake than mimesis, what may be identified as central to art?

In early modern Europe, some philosophers proposed that works of art involve the expression of feelings. The nineteenth-century novelist (and philosopher of art) Leo Tolstoy was a

prominent advocate of this view. He held that in most works of art, an artist has a feeling and then conveys that feeling to audiences through words, material objects, signs. When successful, the artist infects the observer with the artist's feelings. In his book *What is Art?* Tolstoy writes 'Art is a human activity consisting in this, that one man consciously, by means of certain external signs, hands on to others feelings he has lived through, and that other people are infected by these feelings and also experience them' (Tolstoy 1960, 51).

Leo Tolstoy (1828–1910) was not just a great novelist and author of short stories and plays. He was also an important philosopher of art as well as a progressive thinker who published on politics, education, and religion. In developing his communication theory of art, he rejected the idea that beauty is the purpose or goal of art. By his lights, if a work of art fails to achieve a union of artist and audience affectively, then the work fails. Tolstoy linked his evaluation of art to his high view of the love of God and fellow humans, concluding that works of art that do not involve such divine-/human-loving communication are bad art. On this front, he condemned his own early artwork as bad, along with work by Shakespeare and Wagner.

Tolstoy's account does seem to cover some works of art, including his own novels. His theory has been described as *romantic*, insofar as it involves feelings. His account may also be thought to have merit as Tolstoy is among a handful of artists to have contributed to the analytic search for a definition of art. Even so, Tolstoy's account faces some difficulties of being either too broad or too narrow. It may be too broad in the sense that ordinary emotional communications would then be works of art. Some philosophers (including R.G. Collingwood) are prepared to think that all speech acts are works of art. There may be grandeur to that view (which we will return to below)

but at least initially it seems to run counter to the ways in which we normally think of works of art. The worry is that if every expressive act is a work of art, would we have a way to identify what is special about works of art? And Tolstoy's account may be too narrow in the sense that some artists may feel either no particular feelings in their art-making (minimal art or art that seems explicitly based on an absence of feeling) or perhaps even quite different feelings than those expressed in their artwork. An angry artist may only produce works that 'infect' observers with passive contentment. Actors may engage in method acting but not necessarily. Moreover, it seems that works of art may have emotive, aesthetic features even if no actual persons present are having the relevant feelings. We can well imagine that the titanic conclusion of Beethoven's Ninth Symphony would still be joyous even if all of the musicians and members of the audience were in a deep, soulless depression.

The latter case has prompted philosophers to think that works of art actually embody feelings. Susanne Langer developed a rich aesthetic in which works of art embody the forms of human feeling. Paintings, poems, sculpture, dance, music, and so on, may be seen as expressive of a host of emotions from anger and love to disappointment, confusion, and joy. Arguably, the joy we hear when listening to the *Ode to Joy* is not simply a felt association of the music with joy; rather, we can hear the joy in the music. Langer proposed that 'Music is a tonal analogue of emotional life' (Langer 1953, 27). Joyful music is not (literally) joyful but joy is experienced as embodied or extended in the music.

This embodiment or expressive account (in which artwork has forms expressive or symbolic of human feeling) may seem to invite a kind of aesthetic animism – the idea that works of art themselves have feelings. Some art theorists do not shy away from such animism. W.J.T. Mitchell wrote a book called *What Do Images Want?* Answer: they want you to look at them. An expressive account of works of art can enhance (or at least it does so in my experience) one's encounter with works of art.

Here is an experiment: When you next see a work of art, engage it in 'conversation'. Ask, how is it feeling? Apart from possibly being embarrassed in front of a museum guard, your experience may surprise you. Instead of seeing a painting (for example) as a cold or dead object, it may reveal a host of feelings. There is something shy about some works of art, while others are boastful. Obviously, we are now dealing with metaphors (the painting isn't shy, *literally*), but for all that the experience of a work of art can be experienced as rife with emotive, affective features. John Updike once remarked, 'I think books should have secrets as a bonus for the sensitive reader' (cited by Carroll 2001, 9). Of course, Updike may simply be referring to the desirability of authors keeping some parts of their plot unrevealed, but isn't your experience of a book enhanced if you think that the book itself has a secret?

Both the communication and expressive or embodiment accounts of works of art have merit. Some advocates of a communication model point out that sometimes an artist needs to find the words, shapes, and movements in making works of art in order for an artist to fully grasp what she is seeking to communicate (R.G. Collingwood). This surely does capture what some artists report. And the expressive or embodiment model does seem to capture the evocative, rich experience we can have with artwork. Still, more work is needed to elucidate the nature of art. Arguably, lots of gestures and things have expressive features; for example, my office right now can plausibly be experienced as a kind of mysterious, troubling academic wilderness, but it's not thereby a work of art.

Works of art and aesthetic experience

In the twentieth century there emerged a pervasive stance that identifying works of art involved aesthetic experience. In one version, X is a work of art if and only if X was made to be the object of aesthetic experience. Aesthetic experience was

defined in contrast to practical experience. To have an aesthetic experience, one needs to step back or detach oneself from the urgency and practical preoccupations of life. In a very famous example, Edward Bullough asks us to imagine a dangerous fog at sea. When we experience the fog as an occasion for danger, we are not in the position of aesthetic experience.

> Imagine a fog at sea: for most people it is an experience of acute unpleasantness. Apart from the physical annoyance and remoter forms of discomfort such as delays, it is apt to produce feelings of peculiar anxiety, fears of invisible dangers, strains of watching and listening for distant and unlocalised signals. The listless movement of the ship and her warning calls soon tell upon the nerves of the passengers; and that special, expectant, tacit anxiety and nervousness, always associated with this experience, make a fog the dreaded terror of the sea (all the more terrifying because of its very silence and gentleness) for the expert seafarer no less than for the ignorant landsman.
>
> (Bullough 1912, 88)

However, once the practical and dangerous conditions pass, we are then able to appreciate its aesthetic qualities. We might then take note of the sensuous nature of the fog, its silky quality, and so on. Immanuel Kant laid deep stress on the detached, disinterested nature of aesthetic experience, especially concerning beauty. Kant maintains that our focus should be on the representation or appearance of what is. With art it should be on this representation without concern for what is 'the real existence' of things (Kant 1982, 42–3).

Perhaps one of the more radical claims about art and aesthetics being detached from practical engagement has been made by Clive Bell:

> ... to appreciate a work of art we need bring with us nothing from life, no knowledge of its ideas and affairs, no familiarity with

its emotions. Art transports us from the world of man's activity to a world of aesthetic explanation. For a moment we are shut off from human interests; our anticipations and memories are arrested; we are lifted above the stream of life.

(Bell 1958, 27)

In nineteenth- and much of twentieth-century aesthetics, the ability to stand back from practical circumstances came to be seen as a hallmark of works of art. The novelist Balzac notes that it was by stepping back that he was able to more freely enter imaginatively into the lives of others:

On hearing the people of the street, I was able to wed myself to their life; I felt their rags on my back; I walked with my feet in their torn shoes; their desires, their needs, everything passed into my soul passed into theirs ...

(Honoré de Balzac, in Parker 1916, 16)

The aesthetic experience can free us from our self-preoccupation and assist us in taking seriously radically different lives and points of view. Schiller testified to a similar way in which withdrawal can allow for a more expansive purview:

As long as man ... is merely a passive recipient of the world of sense, i.e., does no more than feel, he is still completely One with that world; and just because he is himself nothing but world, there exists for him no world. Only when, at the aesthetic stage, he puts it outside himself, or contemplates it, does his personality differentiate itself from it, and a world becomes manifest to him because he has ceased to be One with it.

(Schiller, in Schiller, Wilkinson, and Willoughby 1982, 183)

In the second half of the twentieth century Monroe Beardsley was the foremost defender of an aesthetic account of art. For a

systematic, fascinating tour of Beardsley's position, see his book *Aesthetics*. The definition of works of art as objects made to be the object of aesthetic experience has several implications.

The aesthetic model of art secures the artifactual nature of art: works of art must in some sense be intended. So natural objects – objects not made intentionally – would not be works of art. At this point, however, a defender of the aesthetic account of art might want to allow that an artist might 'make' a work of art only by intentionally selecting natural objects to be subjects of aesthetic experience. So, a work of art may consist of found objects (*objets trouvés*) but they become works of art because someone (the artist) selects them for viewing. This is presumably what took place in Duchamp's *Fountain*. Even so, the selection would seem to have to require the artist giving the objects some kind of frame or context. Just roping off some part of a forest and claiming this is your creation would seem to not make the grade. Some of Andy Goldsworthy's work comes close to this, but (so far) he always introduces some sculptural elements. Goldsworthy still moves and shapes earth, flowers, ice, stone, mud, twigs, and so on; he does not simply frame natural settings. Works made by persons or things not intending the objects for aesthetic appreciation, such as paintings made by nonhuman animals, the severely mentally damaged, and very young children would not be clear cases of works of art. Alternatively, if one could show that some nonhuman animals, the severely mentally damaged, or very young children could conceive of making objects for the sake of aesthetic experiences, they may all qualify as artists. There is another option: the aesthetic definition of art may be able to accommodate such objects on the grounds that they have been identified by artists or curators as objects for aesthetic experience. In this case, a curator may function as an artist insofar as she identifies objects for aesthetic purposes.

The aesthetic model also seems to be able to accommodate objects that have a practical use and yet have rich aesthetic features.

Consider, for example, Shaker furniture. The Shakers were a religious movement that began in the eighteenth century which produced (among other things) beautiful furniture. A Shaker chair may function as a chair and yet it has elegance, even beauty. Here one can endorse a binocular or both/and view. The chair qua piece of furniture has a practical function and insofar as it is not made to be an object of aesthetic experience, it is not a work of art. But insofar as it was made to be observed aesthetically (and is so observed), the object can function as a work of art. Timing may enter into when an object is a work of art. Nelson Goodman's title for a clever paper is telling: 'When Is a Work of Art?' The chair may be merely a chair as you gather around a table for a meal, but it can become a wall sculpture once you stop using it as merely a piece of furniture, and hang it on a museum wall.

This aesthetic account of works of art has many advocates today. But it does indeed need defense for several reasons.

There is the problem of works of art that seem to be profoundly anti-aesthetic. The classic example is Duchamp's *Fountain*, cited earlier, a urinal that Duchamp selected to be mounted as a work of art (see Figure 3). It seems that the whole point of the work of art is to oppose aesthetics, not support it. Another example is John Cage's composition 4'33", which consists of a performer being on stage for four minutes and thirty-three seconds of silence. Likewise, there is Robert Rauschenberg's piece *Erased de Kooning Drawing*, in which he took a drawing by de Kooning, erased it, and then titled and exhibited the work as his own. Timothy Binkley concludes that contemporary art is no longer tethered to aesthetic experience: 'Art in the twentieth century has emerged as a strongly self-critical discipline. It has freed itself of aesthetic parameters and sometimes creates directly with ideas unmediated by aesthetic qualities. An artwork is a piece; and a piece need not be an aesthetic object, or even an object at all' (Binkley 1996, 89). So, according to the first

objection, making something for aesthetic experience does not seem to be a necessary condition for an object to be a work of art.

Another problem is that the concept of aesthetic experience (as customarily described) seems extraordinarily vague. The title of a famous paper by George Dickie is representative of a skeptic's counter-move: 'The Myth of the Aesthetic Attitude'. Efforts to pin down exactly what counts as an aesthetic experience versus a non-aesthetic one are notoriously difficult. If we simply mean by 'aesthetic experience' something pleasing or emotionally interesting, then almost anything (Italian motorbikes) can turn out to be works or art.

There is also the problem that aesthetic attitudes or experience (when it is described) seems too passive, whereas many works of art involve problem-solving, moral challenge, interpretation, religious rituals, and so on. It has been argued that the aesthetic theory of art may reflect a Euro-centric, modern outlook which prizes detachment and disinterest. On the aesthetic account, it seems that many objects that seem to be works of art (religious icons, African masks) would not be art, because they were made for specific ritual ends and not for detached, disinterested contemplation.

Finally, it has been argued that the aesthetic model and the others we have considered (art as mimesis, communication, expression or embodiment) assume there is an essence to works of art. Some philosophers regard this thesis as not just suspect but stultifying (Morris Weitz). Why not adopt a more open-ended model that gives greater liberty to the artworld? In fact, why not call into question the notion that art has to be an artifact? After all, it seems a bit strained to claim that Duchamp *made* the artwork *Fountain*. And in *Erased de Kooning Drawing* it seems that Rauchenberg actually destroyed a work of art rather than made one. So these two works can support two objections: why think art has to be aesthetic?

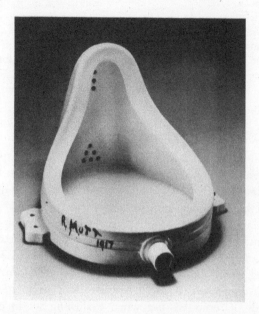

Figure 3 Marcel Duchamp, *Fountain* (signed 'R. Mutt') (1917), ready-made, original destroyed.

Marcel Duchamp (1887–1968) was a French artist who challenged the boundary between works of art and everyday objects. He would take an ordinary object like a urinal, adjust it slightly, and then submit it as a titled artwork for exhibition. These artworks have been called ready-mades or 'found art'. Apart from his work *Fountain* he is famous for his 1919 work in which he took a photograph of Leonardo da Vinci's *Mona Lisa* and added a moustache, goatee and label or title: L.H.O.O.Q. As an artist or anti-artist, Duchamp's work raised questions about the meaning of art and aesthetics. A more recent example of institutionally recognized works of art that raise questions about the limit and power of art can be found in the work of Andy Warhol (1928–87). Two of his

> more well-known bodies of work that challenge the status quo are
> his paintings of Campbell's soup cans and his sculpture of boxes
> of Brillo soap pads built out of plywood and painted to look like
> ordinary boxes of the household cleaning product.

Is the aesthetic theory dead in the water? This is doubtful as
there are plausible replies to the above objections. A full reply
first needs to further clarify the meaning of aesthetic experience.

The aesthetic may be taken to refer to affective or emotive
properties. As such, almost any experience whatsoever may have
some aesthetic dimension. So, one's experience may be said
to have an aesthetic dimension to the extent that it involves
experiencing objects as joyous, elegant, enchanting, bewitching,
effusive, menacing, melancholy, moody, sad, and so on. In this
extended sense, almost *all* our experience has or can have an
aesthetic dimension. Such an emotive layer seems to pervade
the kinds of terms we use when evaluating works of art as
brilliant, witty, deeply moving, fresh, bold, repetitive, dull,
boring, listless, superficial and derivative, and so on. And the
aesthetic theory can also be seen as drawing upon how we
ordinarily perceive the world. Rudolph Arnheim observes how
our observations of people and things are shot through with
affective features:

> We perceive the slow, listless, 'droopy' movements of one
> person as contrasted to the brisk, straight, vigorous movements
> of another ... Weariness and alertness are already contained
> in the physical behavior itself; they are not distinguished in
> any essential way from the weariness of slowly floating tar or
> the energetic ringing of the telephone bell ... A steep rock,
> a willow tree, the colors of a sunset, the cracks in a wall, a
> tumbling leaf, a flowing fountain, and in fact a mere line or
> color or the dance of an abstract shape on the movie screen

have as much expression as the human body, and serve the artist
equally well.

(Arnheim 1974, 433)

What distinguishes works of art from ordinary objects is that
works of art are made for the sake of such experiences. One
more condition must be added: works of art are made for
the appreciation of such experiences. 'Appreciation' need not
involve enjoyment or pleasure, but it must involve an evaluative
component. In an important, new defense of an aesthetic
theory of art, appropriately titled *The Aesthetic Function of Art*,
Gary Iseminger defines appreciation succinctly: 'Appreciation is
finding the experience of a state of affairs to be valuable in itself'
(Iseminger 2004, 36).

Let's now go through the objections. What about anti-
aesthetic art? Paradoxically, it may be argued that there is an
aesthetic to being anti-aesthetic; its features include emotions like
boldness, challenge, effrontery, abrasiveness, coldness, humor.
Consider some of the most severe, apparently anti-aesthetic works
of art. What about Duchamp's *Fountain* or John Cage's 4'33"
or *Erased de Kooning Drawing* or Andy Warhol's Brillo boxes
(replicas of a box for a cleaning product)? These still have affective
features involving play, challenge, and self-consciousness; they
are designed to stimulate reflection on art and culture. John Cage
seems to have recognized the unavoidability of what we may call
aesthetics. Cage claimed, 'There is no such thing as empty space
or an empty time. There is always something to see, something
to hear. In fact, try as we may to make a silence, we cannot'
(Cage 1961, 149). Rauschenberg's piece also succeeds (if it does)
due to the felt affrontive (offensive) tone of the piece. The piece
would not be interesting unless it was experienced as transgressive.
And the same seems to be true for *12 Square Meters*, *The Physical
Impossibility of Death in the Mind of Someone Living*, and *Helena:
The Goldfish Blender*.

Consider an analogy with what may be called anti-philosophy philosophy. Wittgenstein's later writings have been interpreted as arguing against philosophy, or at least against its historical character. But insofar as the anti-philosopher engages in philosophical arguments it is difficult to see that he has left philosophy behind. Similarly supposed anti-aesthetic art seems to itself have aesthetic dimensions, even if those features are subversive, violations of the status quo, and questioning. This response to anti-aesthetic art also seems to push back against the objection that the aesthetic model is overly passive. After all, there seems to be an aesthetic involved in problem-solving, thinking and acting morally, and so on. Appreciable affective properties are especially important in artwork that is confrontational and invites observers to engage in self-questioning.

If aesthetic experience and appreciation are given sufficient breadth, there is no danger of confinement or art theory holding back the artworld. Such breadth can also explain why some philosophers like Collingwood might well think of life itself or one's speech as works of art. While there is some reason to resist such a promiscuous use of the term 'work of art', one can indeed appreciate the affective dimensions of someone's life and their speech. One may well contemplate a lifetime as beautiful or a blend of beauty and ugliness.

This broader concept of aesthetics may further assist us in replying to Plato's objection that poetry lacks a *techne*. On the aesthetic model, the artist is someone who is skilled in aesthetic invention and observation. She or he is able to resonate with and creatively represent, communicate, express, and imitate aesthetically charged objects and events.

The scope of the aesthetic model can also encompass models of art we have not enough space to cover. Sigmund Freud, for example, analyzed works of art as waking dreams. Yet another model of art likens artwork to play or pretense (make-believe). All these have their own affective or emotive tones that may be

appreciated for their own sake and for the light they can shed on some works of art.

The aesthetic model is not the most recent model. We now need to turn to the latest, institutional account of art.

The artworld and the definition of a work of art

The most recent development of a theory of art is often called the institutional theory. Some philosophers who are dissatisfied with the aesthetic model have looked to this alternative that gives center stage to the artworld as an institution. In *Art and the Aesthetic: An Institutional Analysis*, Dickie contends that almost anything can become art if the artworld confers upon it this status of 'art' (Dickie 1974). This is surely quite open-ended. The main components of the artworld are described as follows:

> An artist is a person who participates with understanding in the making of a work of art.
>
> A work of art is an artifact of a kind created to be presented to an artworld public.
>
> A public is a set of persons the members of which are prepared in some degree to understand an object which is presented to them.
>
> The artworld is the totality of all artworld systems.
>
> An artworld system is a framework for the presentation of a work of art by an artist to an artworld public.
>
> (Dickie 2004, 58)

Dickie's characterization of art and the artworld may seem suspiciously circular – as in making a claim like 'art is what artists make' (compare 'science is what scientists do'). But his account singles out the artworld as a self-identified, interwoven,

observable system with its art market, museums, art criticism, and so on. Dickie's account is functional and procedural, offering a guide to locating works of art.

Arthur Danto also advanced a similar open-ended definition of artworks as objects that are recognized as art by the artworld, but he offered a more substantial picture of the nature and role of artworks. Danto claimed that works of art have a place in art history and they are about the world and require interpretation in a way that ordinary objects are not (Danto 1981, 52). As Danto puts matters in a famous article *The Artworld*, 'To see something as art requires something the eye cannot decry – an atmosphere of artistic theory, a knowledge of the history of art: an artworld' (Danto 1964, 580).

Arthur Danto (b.1924) is an American philosopher and art critic who insured that the philosophical practice of aesthetics paid close attention to contemporary practicing artists. According to Danto, without such contemporary engagement, one is left with (in a phrase made famous by Australian philosopher John Parsmore) 'the dreariness of aesthetics'. Danto's theory of art – with its focus on the artworld and art history – was explicitly crafted to account for why ordinary objects like Brillo the household cleaning product is not a work of art, and yet Andy Warhol's *Brillo Boxes* are artworks. Danto proposed that, suitably situated in the artworld and art history, works of art have an 'aboutness' so that Warhol's *Brillo Boxes* are about art itself (as well as being about popular and commercial culture). Danto contends that with Warhol's work, the artworld achieved a self-consciousness in which some art becomes essentially philosophical.

Between Dickie and Danto, Danto's account seems to offer more in terms of substance, though both his and Dickie's models are promising. They still, however, seem to face challenges.

Against Dickie: why think of works of art as *essentially* institutional? Why can't there be works of art quite independent of whether there are any institutions in play to recognize such works? The aesthetic theory of art can allow for what seems to be the genuine possibility of there being an artist who creates something for aesthetic experience, but it is never recognized by the artworld public or system. Dickie's account seems to leave us in the dark about why it is that the artworld recognizes some objects as art and not others. When a museum or art center or gallery decides to exhibit an object as art, they may well consider past and present practices of art institutions, but if we ask why these institutions did what they did, we seem to be on an unhelpful regress, for did *these* institutions only act in virtue of what *other* institutions did? This is doubtful (Beardsley 1982, 125–43). One of the difficulties facing the institutional theory is that it leaves the artworld itself with no guidelines and it leaves the individual artist without guidelines as well. Consider Binkley's more individualist definition of art: 'To be a piece of art, an item need only be indexed as an artwork by an artist ... Anyone can be an artist. To be an artist is to utilize (or perhaps invent) artistic conventions to index a piece' (Binkley 1987, 96). This may sound liberating, but doesn't this drain the concepts of being *an artist* and *work of art* of all meaning? And contrary to institutional theories that require art objects having a place in art history, what about the first artwork? Did the object only become an artwork until it was discovered? Arguably, the concept of a work of art needs to be broader than one that requires institutional or historical identification.

Still, debate continues and there is even the possibility of combining the different theories or using a different model for different forms of art. For example, some works of art seem to involve the communication of emotions, and for such works, Tolstoy's model seems the best guide.

Could food be a work of art? Some philosophers such as Elizabeth Telfer are prepared to think that some food dishes might be classifiable as works of art. Food and drink can be intentionally made to be the object of aesthetic pleasure, both visually as well as in the gustatory and olfactory modes. Food can be arranged in representational and expressive ways and be vehicles of communication. Dishes of food may be transitory but so are cases of music. Food has been incorporated in recognized works of art (think about still life painting, portrayals of meals (for example, *The Last Supper*) in paintings, food in film, and photography, poetry, and sculpture). Perhaps we are reluctant to think of dishes of food as beautiful or sublime or deserving of awe, or to speak of food moving us emotionally the way we might be moved by a great novel. But perhaps this is because we haven't had or seen such a worthy dish yet or because our attitude toward food isn't what it should be. Telfer herself who defends food as art does not claim that all food can be on a par with great art, but she nonetheless recommends that we be open to thinking that some dishes of food are the outcome of what she calls a minor art.

3
Art and meaning

What do works of art mean? Could the meaning of a work of art change from time to time? Can an artist make her work have a given meaning by simply declaring what she was trying to express or create in her work?

The intentions of the artist

One of the most hotly debated topics on the meaning of works of art involves artistic intentions. When, if ever, should we take into account the intentions or goals of the artist? In 1954 W.K. Wimsatt and Monroe Beardsley published an important essay, 'The Intentional Fallacy'. In it, they argued that art criticism should not focus on the life and intentions of the author. They maintained that what the artist intended is irrelevant to assessing the work itself. This is partly due to the fact that the artist's intentions are often unrecoverable. As they put it, 'Critical inquiries are not settled by consulting the oracle.' Wimsatt and Beardsley sought to replace art critical terms like 'sincerity' (for example, Dostoevsky wrote *The Brothers Karamazov* in a sincere effort to make a case for Russian Orthodox Christianity) with terms that referenced instead only features of the work of art itself. This shift in critical attention from the artist to the work of art had a tangible impact on art criticism. Wimsatt counseled a shift in the vocabulary of art theory:

> It would be convenient if the passwords of the intentional school, 'sincerity', 'fidelity', 'spontaneity', 'authenticity', 'genuineness',

'originality', could be equated with terms such as 'integrity', 'relevance', 'unity', 'function', 'maturity', 'subtlety', 'adequacy', and other more precise terms of evaluation – in short, if 'expression' always meant aesthetic achievement.

(Wimsatt, in Wimsatt and Beardsley 2008, 550)

The drive to focus only on works of art themselves without reference to the interior life and biography of the artist became a dominant force in post-World War II art criticism. With the help of T.S. Eliot, appeals to authorial intent in determining meaning came to be viewed as fallacious, a case of an invalid inference.

This move away from focusing on the author-artist was radical and widespread. In what is sometimes called 'New Criticism', the older, expressive theory of art was utterly rejected. As representative of expressive theory (noted in the last chapter) consider R.G. Collingwood's account of good and bad art:

What the artist is trying to do is to express a given emotion. To express it and to express it well, are the same thing. To express it badly is not one way of expressing it ... it is failing to express it. A bad work of art is an activity in which the agent tries to express a given emotion, but fails. This is the difference between bad art and art falsely so called ... In art falsely so called there is no failure to express, because there is no attempt at expression; there is only an attempt (whether successful or not) to do something else.

(Collingwood 1938, 282)

In light of the new criticism ushered in by Beardsley and Wimsatt, all interest in what emotions an artist may or may not have intended to express is ruled out in aesthetics. We must, instead, focus on works of art themselves and not the minds or feelings behind the work.

Part of the reason behind the dismissal of artistic intentions was a sense that works of art are primarily public objects. Arguably, art is like public language which has a meaning that is not subject to intentional whims. So, for example, someone may make a sexist remark and the remark remains sexist even if the speaker claims he didn't mean it to be sexist. It was also thought that if we were to give intentionality primacy, artistic success would become too easy and thus facile. A sculptor may create something rather feeble (a bound collection of old newsprint) and call it 'Human History', but why should we grant the artist any kind of success in this matter?

Monroe Beardsley (1915–85) was an American philosopher devoted to an aesthetic account of art. The aesthetic experience of art and natural objects involves coherence, a felt unity, and completeness. But his equally important contribution to art theory was his claim that knowledge of the intentions of an artist is not relevant to the understanding and evaluation of art objects. Along with W.K. Wimsatt, he supported the view that art criticism should only involve publicly accessible, objective facts and criteria. A work of art should be treated as an object that has an autonomous life independent of the artist's stated (or unstated, ulterior) motives and intentions.

There are, however, some reasons to resist Wimsatt and Beardsley. First, if a work of art explicitly involves the artist him- or herself the division between the artist and the work collapses. Artists like Andy Warhol and Chris Burden so involved themselves as works of art that it would be difficult to separate artist and art. They each did art that involves their bodies. Also, in practice it became very difficult (despite protests by T.S. Eliot and others) to view some art, such as the poetry of Ezra Pound, as utterly cut off from biography, especially as Pound

himself described his enthusiasm for Italian fascism as aesthetic. We will explore the relationship of art and ethics in the next chapter.

Second, certain attributes of works of art have implications about an artist's intentions. If a work of art is described as intelligent or witty or insightful, this seems to imply that the artist is (at least when she executed the work) intelligent, witty, or insightful (see Lyas, 1997). Haydn's Quartet in E flat (Opus 33, No. 2), often referred to as 'The Joke', is rife with humor. Consider this account of the wit involved:

> The quartet acquired the nickname *The Joke* because of the enigmatic rests at the end of the finale, but humor pervades the whole movement, as Haydn deliberately plays with the players' and listeners' expectations ... After a pause prolongs the drama, Haydn surprises us with a witty letdown – a simple return of the refrain's opening period. Haydn follows the same strategy at the end of each episode, so that each return of his comic opening melody is preceded by a disproportionately dramatic buildup ... Haydn seems to be poking fun at the redundant rondo, the beat-counting musicians, and the listeners wondering when to applaud.
>
> (Burkholder 2005, 109–10)

Notice the way the account of humor provides a useful interwoven portrait of intentions and features of the work itself.

As for works of art being public, like language, it is hard to avoid intentions. Imagine a case that appears sexist. A man walks into a room and says 'Look at the bitch!' and everyone assumes he is referring to a woman, but he is actually referring to the huge female dog that is nursing puppies and let us imagine the man is not a native English-speaker and is not familiar with slang. Did he say something sexist? He said something that is naturally

interpreted as sexist, but once his intentions are revealed one may see that it was an innocent remark.

Does the intentional criterion make the meaning of art too easy? This seems doubtful. Back to the imaginary 'Human History' sculpture, if the artist's intentions are sincere, we can well claim that he tried to do something about human history, but then critique his efforts to make the piece about human history and not about recycling or journalism or newspapers.

Let me also add a personal anecdote about meaning and intentions, and the need to appeal to intentions in getting at meaning. During a job interview, a dean of a university told me he initiated a kind of Wagner circle, prompting many faculty to regularly attend Wagner opera. Without any reflection I said, 'Ah, so you are the ring leader.' My host laughed, noting I was very clever. Was I? Only if I had made some connection between my host and Wagner's *Ring Cycle*. Perhaps I did on some subconscious level, but I suggest that without the proper intention what I said was no more clever than if a class in British history was asked about the Battle of Hastings and a student was heard saying '1066' but only because that is his phone number and he was unintentionally overheard giving it to a classmate.

Intentionality also seems important concerning the display of art. The intention of the artist seems to be a key reference point as to how the work is to be viewed. Was a sculpture made only to be seen from twenty yards away and not up close? Was it made only for viewing in a garden or natural setting so that it may be viewed aesthetically in relation to the world and not inside a building? These questions seem to require authorial intent to determine how works of art are framed and displayed. While some reference to the intentions of the artist do seem relevant to the meaning of a work of art, Wimsatt and Beardsley seem right that we do face a very difficult problem in deciphering those intentions. This is why it may be that what we need to appeal

to is either the *presumed intent* of a piece and what some call *the implied author* or *artist*. In the absence of clear instructions from an artist and lacking oracles, we may need to be guided by what we assume the artist intended. In any case, knowing something of the intentions and life of the artist can deepen one's experience of the work itself. Consider, for example, Beethoven's *Heiligenstadt Testament* (1802). Beethoven faced the fact that his deafness was progressing, and probably incurable. The composer describes his current hopeless state of being at the time of composition. He writes, 'I was not far from ending my own life – only Art, only art held me back' (Weiss and Taruskin 2007, 277). Arguably, Beethoven's Fifth Symphony exemplifies the titanic struggle with which the composer is wrestling. This particular work seems to be an exegesis of Beethoven's difficult journey through life, and knowing this background can allow us to enter into deeper layers behind and in the music.

It seems, then, that whether a work of art is displayed in a dark room, sunlight, or on a rotating pedestal seems to be properly determined by what we presume the artist intended. Imagine Jackson Pollock wanted his later work only viewed at twilight in a garage. If so, there is a sense in which when you see Pollock's later work at the Museum of Modern Art you are not actually looking at Pollock's works of art, but you are seeing them as-they-have-been-put-in-a-light-that-was-not-properly-framed.

While there are some reasons for questioning New Criticism, there remain some reasons to be wary of going back to an expressive theory and giving *exclusive* attention to authorial intent. While we do have some access to Beethoven's mind at the time of the composition of his Fifth Symphony, knowledge of precise details of intentions are notoriously difficult to identify. James Young appeals to that elusiveness in his argument against those who identify 'authentic musical performances' in reference to the intentions of the composer:

If it were available to an Omniscient Musicologist, it would still not determine which performances are authentic. Even complete reports of a composer's own performance of a solo piece would not be decisive evidence. There is no guarantee that even a composer's own performance realized his intentions. Not even a composer's own reports would be decisive evidence. The knowledge of how a piece is to be interpreted is, in large measure, practical knowledge, a knowledge of how something is to be done. Such knowledge, like the knowledge of how to ride a bicycle, cannot be fully captured in propositional terms. Not even the composer will be able to describe precisely what his intentions were. If we cannot know what a composer's intentions were, we cannot determine which performances are authentic and which are not ...

(Young 2003, 73)

Granting Young's point, intentionality cannot be the full story of the meaning of a work of art, but we may be throwing the baby out with the bathwater if we ignore intentionality altogether.

History, culture, and meaning

There are two general accounts of the meaning of works of art that are associated with Kant and Hegel. According to what may be called a Kantian aesthetic, the formal aesthetic properties of a work of art are definitive or the key reference point in the work. From a Hegelian point of view, the key is historical, cultural context. Both views have merit and they need not stand in stark contrast.

A Hegelian approach is difficult to avoid in assessing works of art that involve explicit references to historical events. The *1812 Overture* makes little sense without some reference to Napoleon.

Aeschylus' *The Persians* is difficult to see without some awareness of the historical triumph of the Greeks in the Persian Wars. Duchamp's *Fountain* seems firmly situated in its historical setting. But some works seem less fixed. One perhaps needs some grounding in Renaissance history to fully appreciate Michelangelo's *David*, but surely one may have a deep appreciation for its elegance, agility, and bold beauty without such an historical grounding. It is probably possible to appreciate Picasso's epic painting *Guernica* as a portrait of the outrageous tragedy of war without knowing its specific historical context. But arguably one appreciates it more when one realizes that Picasso painted it in 1937 to mark the bombing of Guernica by Italian and German warplanes during the Spanish Civil War. An appreciation for the historical setting of a work of art can help us take stock of the expertise and virtuosity involved (was the work executed by a single artist or a whole workshop?), the style of the work (was the artwork part of a tradition?), and the conventions that are important to appreciate in interpretation (what was the conventional meaning of a rose when William Blake wrote 'The Sick Rose'?).

Immanuel Kant (1724–1804) and G.W.F. Hegel (1779–1831) were two highly influential, prolific German philosophers who contributed to virtually every area of philosophy, including aesthetics. The competing views of art they inspired are closely related to their ethical theories. Kant's ethics was not a matter of historical, social conditions, but concerned the value of persons across cultures and time periods. Ethical truth, like the value of beauty, can and in a way should be appreciated from an impartial point of view. Hegel instead thought that both works of art and morality had to be understood in the context of the history of communities. Kant and Hegel agreed, however, that works of art had to be made or intentionally created. Imagine that an abstract sculpture of

Romeo and Juliet looks indistinguishable from a piece of driftwood randomly produced by waves, water, shells, and so on. Kant and Hegel would claim that the first object had an 'aboutness' or meaning (it is about the tragic, young love made famous by Shakespeare, for example) that the second object lacked.

When does the cultural context of art-making affect the meaning of a work of art? We will examine cultural aesthetic traditions at greater length in Chapter 6, but for now we may provisionally grant that cultural setting can indeed shape the meaning of a work of art. For example, Rublev's icon of the Trinity seems inextricably bound up in the tradition of iconography which sees the image as a reflection of the Godhead, as understood in Russian Orthodoxy (see Figure 4).

Consider another case, this one involving Hindu art and aesthetics. In Figure 5 we see an excellent example of art in Hindu tradition. Here are some verses from the *Tirukuttu Darshana* (Vision of the Sacred Dance, celebrating the dance of Shiva):

His form is everywhere: all-pervading in His Siva-Sakti;
Chidambaram is everywhere, everywhere His dance;
As Siva is all and omnipresent,
Everywhere is Siva's gracious dance made manifest
His five-fold dancers are temporal and timeless
His five-fold dancers are His Five Activities.
By His grace He performs the five acts,
This is the sacred dance of Uma-Sahaya.
He dances with Water, Fire, Wind and Ether.
Thus our Lord dances ever in the court.
Visible to those who pass over Maya and Mahamaya [illusion
 and super illusion]
Our Lord dances his Eternal dance.
The form of the Sakti is all delight –

Figure 4 Andrei Rublev, *The Trinity* (c.1410), Tretyakov Gallery, Moscow (photo: Wikimedia Commons).

This united delight is Uma's boy;
This form of Sakti arising in time
And uniting the twain is the dance:
His body is Akas, the dark cloud therein is Muyalaka,
The eight quarters are His eight arms,
The three lights are His three eyes,
Thus becoming, He dances in our body as the congregation.

(cited by Coomaraswamy 2005, 259)

The Lord Shiva statue seems to be an excellent case of when our experience of artwork is enhanced by knowledge of historical and cultural background. The poetic praise of Shiva allows us to see the cosmic significance of the sacred dance. And without this

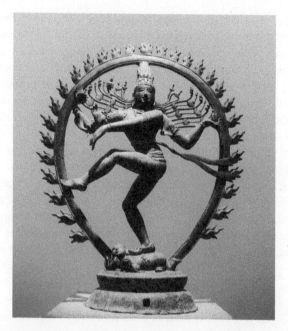

Figure 5 *Lord Shiva*, statue (fifth century), Chidambaram Nataraja Temple, Tamil Nadu (photo: Vassil/Wikimedia Commons).

background knowledge the statue would be more opaque and baffling, rather than enriching and enticing.

Historical and cultural conditions are often vital (sometimes more than others) to determining the meaning of a work of art. But sometimes works can have power and beauty irrespective of context. Moreover, once one distinguishes between, say, a play and a performance, we may well have circumstances in which a current performance of a play has a meaning that is quite independent of its original setting. For example, it is plausible to interpret Aristophanes' fourth-century BCE play *Lysistrata* as an anti-war play (women go on a sex strike to try to stop the

war between Athens and Sparta) and that is the most common interpretation of modern performances of the play. It is possible, however, that the play was originally perceived as a comic denigration of women rather than a comic affirmation of women. If that is a fact, that need not entail that current performances of the play denigrate women. Indeed, current performances may be profoundly affirming of female wit and wisdom, irrespective of the original setting of the play.

On at least one point, historical context seems vital and that concerns originality. The title of a recent article aptly sums up the role of history: 'So you want to sing with the Beatles? Too late.' Today, if you proposed to exhibit a urinal in a museum, it would naturally (and perhaps quite rightly) be seen as commenting on Duchamp's *Fountain*, just as you would be seen as either quoting or performing or referencing a Beatles' 1967 album if you started singing 'With a little help from my friends' with the same melody Ringo Starr put to good use. Viewers and audiences would naturally see the meaning of your work in light of the earlier work even if (by some kind of miracle) you had no awareness of Duchamp and the Beatles.

Gender

Sometimes the gender of the artist seems quite irrelevant to the meaning of works of art, but not always. First, there is the phenomenon that some call 'the male gaze', a reference to the thesis that women are portrayed historically in the arts in terms of or in reference to an objectifying male viewer. In this framework man is the one who gazes at the woman as the object of his desire. Concepts of female beauty sometimes reflect what males believe, expect, and desire, rather than reflect principally a woman's viewpoint or a genderless point of view (if that is even possible). In the feminist critique of the male gaze, the

objectifying element is understood as male but it can be taken up by women; women, in other words, may look at women with the values and objectification stemming from male desire. A woman might see herself as she wants men to see her. Mary Devereaux offers the following observation of the male gaze in films:

> What does it mean then to say that at this level the gaze is male? It means that despite the presence of women directors and screenwriters, the instructions of film-making remain largely populated by men. Not all films have male authors, but whoever makes movies must work nonetheless within a system owned and operated by men. At the level of the filmmaker, then, men do not always do the looking, but they generally control who does. The male gaze is not always male, but *it is always male-dominated*.
>
> (Devereaux 2003, 385)

Whether or not artwork is produced under such objectifying conditions seems to be an important element in its meaning. At an extreme, when paintings, photographs, films, and so on are so geared toward arousing and exciting desire, the work at hand may seem more like pornography than erotic art.

Second, it has been argued that traditional works, such as some traditions of textiles, that have not been recognized as works of art, may reflect male bias. Actually, the case of textiles is especially revealing of a gender bias, for until recently textiles have been recognized as art when done by men but not when done by women. Feminists have often argued that the canon of what counts as worthy of aesthetic, appreciative experience needs to be expanded. Estella Lauter writes that:

> Feminist theory enhances our experience of art by accounting for it more accurately. It expands the range of what we consider to be art and prepares the way to legitimate new art forms; opens the

community of artists; revalues subjectivity in art and augments it to include women's experiences; allows us to reconnect aesthetic values with political activity; stimulates criticism of obsolete aesthetic standards and validates new ones; valorizes new modes of production; and supports more active responses.

(Lauter 1993, 33)

This wider viewpoint also promotes a more expansive, critical perspective that allows one to lament why there have been fewer women artists recognized in the art historical canon until recent times.

Some works of art seem to explicitly reference the fact that they are produced by women. Judy Chicago's *Dinner Party* may be a good example. The installation consists of a large sculptural platform evoking a dining table and plates decorated with vaginal forms. The fact that this was produced by a woman at the time she did it (1979) seems to be part of the meaning of the work.

In general, gender, sex, and sexual orientation seem to not always be relevant to a work's meaning unless this involves an explicit reference in the work itself or clue to salient historical conditions involving gender. Arguably, Virginia Woolf's *To the Lighthouse* is about gender both because the book addresses the unfair treatment of women artists and because of the life of its famous, feminist author. There is a reason why Virginia Woolf lamented the historical conditions that would have made a female Shakespeare a near impossibility. It is only recently that opportunities for women in the artworld have neared what men have had throughout the modern era.

Interpretations

We come now to a key battleground in aesthetics: can there be more than one meaning to a work of art? Those philosophers

who privilege the intentions of the artist in fixing meaning, tend to distinguish between the meaning of a work of art and its significance. Imagine Harriet Beecher Stowe's *Uncle Tom's Cabin* was not actually written by Ms Stowe. Instead, it was discovered to have been authored by a white, Southern slave owner as a joke as part of a bet that he could simulate abolitionist writing. Under these circumstances, one may well conclude that the *meaning of the work* is ironic for it is not sincerely made, but that the *significance of the book* as a powerful condemnation of slavery remains intact.

Philosophers who are loath to commit the so-called fallacy of appealing to authorial intent are less likely to make the above move. Some philosophers and art critics allow for multiple, shifting interpretations of works of art. So, for example, one may offer the following interpretation of the *Iliad*:

> The true hero, the true subject, the center of the *Iliad* is force. Force employed by man, force that enslaves man, force before which man shrinks away ... The cold brutality of the deeds of war is left undisguised; neither victors nor vanquished are admired, scorned, or hated ... As for the warriors, victors or vanquished, those comparisons which liken them to beasts or things can inspire neither admiration nor contempt, but only regret that men are capable of being so transformed.
>
> (Weil 1941, 163, 190)

This interpretation of the *Iliad* is by Simone Weil, and it reflects (in part) her own critique of western culture. And yet (some argue) it may be equally valid to detect in the *Iliad* a subtle critique of force and *kleos*, or glory. Yes, at the heart of the *Iliad* there is aristocratic, bone-crushing violence, but there is also tender mourning over loss. When Hector takes leave of his wife Andromache for the last time, she urges him to defend their city walls from a safe vantage point. One can vividly sense her

painful longing for the safety of her husband. And when Priam retrieves the body of his beloved, slain son, Hector, it is hard not to be moved when he kisses the hand of Achilles, the man who killed his son.

As you may suspect from earlier observations about intentionality, history, culture, and gender, there is some reason to resist concluding with 'anything goes' in terms of interpreting texts. In the *Iliad*, for example, it seems that we can find some grounding and warrant for Weil's interpretation, but there are also some signs of ambivalence in the poem about force and the ultimate pursuit of *kleos*. Glory is in play, but so is a mourning for its cost, and perhaps the interplay of glory and mourning is what gives the *Iliad* its awesome grandeur. Still, the meaning and significance of works seem to admit of some shifting. Shakespeare's *Hamlet* may have originally been about Protestantism in the early modern era, but its richness seems to admit of such a multitude of layers that any single sense of its meaning and significance must remain fluid.

Over the past fifty years theories of interpretation of art have tended to highlight the way in which both artists and viewers bring in their own preferences and expectations. This is something expressed by the dictum: 'there is no innocent eye'. As E.H. Gombrich remarked, 'Whenever we receive a visual impression, we react by docketing it, filing it, grouping it in one way or another, even if the impression is only that of an inkblot or fingerprint ... [T]he postulate of an unbiased eye demands the impossible' (Gombrich 1960, 297–8). I believe some of the worry about bias can be overdone (after all, maybe Gombrich is only biased – being prey to irrationality or a stultifying prejudice – when he claims no one is or can be unbiased). But a significant number of philosophers treat the interpretation of artworks along the same lines as the interpretation of language. In the last chapter, it was mentioned that Nelson Goodman rejected

the mimetic account. Mere imitation or resemblance does not necessarily establish reference or meaning. In Goodman's view, works of art should be thought of as constituted by symbols and the aesthetic attitude that we take towards works of art should be seen as cognitive; observers of art seek first and foremost to understand the works and its meaning. Goodman recounts two amusing stories about how the reliance upon resemblance can go horribly wrong:

> Let me tell you two stories – or one story with two parts. Mrs. Mary Tricias studied such a sample book, made her selection, and ordered from her favorite textile shop enough material for her overstuffed chair and sofa – insisting that it be exactly like the sample. When the bundle came she opened it eagerly and was dismayed when several hundred $2' \times 3'$ pieces with zigzag edges exactly like the sample fluttered to the floor. When she called the shop, protesting loudly, the proprietor replied, injured and weary, 'But Mrs. Tricias, you said that the material must be exactly like the sample. When it arrived from the factory yesterday, I kept my assistants here half the night cutting it up to match the sample.'
>
> This incident was nearly forgotten some months later, when Tricias, having sewed the pieces together and covered her furniture, decided to have a party. She went to the local bakery, selected a chocolate cupcake from those on display and ordered enough for fifty guests, to be delivered two weeks later. Just as the guests were beginning to arrive, a truck drove up with a single huge cake. The lady running the bake-shop was utterly discouraged by the complaint. 'But Mrs. Tricias, you have no idea how much trouble we went to. My husband runs the textile shop and he warned me that your order would have to be in one piece.'

(Goodman 2008, 440–1)

What we need, instead, is to recognize the practice and function of symbolization that will enable us to 'read' works of art, just as poor Mrs Mary Tricias needed to have a stable interpretive practice with her artisans. Such practices and functions vary depending upon genre, historical context, and so on.

Perhaps the most radical view of the meaning of artwork comes from Jacques Derrida and a methodology of deconstruction. On this view, texts have no stable meaning, as is demonstrated when works of art or texts can be shown to contain conflicted ideas, even contradictory elements. Derrida, however, distanced himself from some of the radical (American) deconstructionists before he died in 2004. A slightly less radical view of the meaning of texts was advanced by Roland Barthes. In a famous essay, Barthes sought to construe 'texts' as fluid objects that may be shaped by readers:

> In opposition to the notion of the work of art or literature there now arises a need for a new object, one obtained by the displacement or overturning of previous categories. This object is the Text ... The Text must not be thought of as a defined object. It would be useless to attempt a material separation of works and texts. A very ancient work can contain 'some text', while many products of contemporary literature are not texts at all. The difference is as follows: the work is concrete, occupying a portion of book-space (in a library, for example); the Text, on the other hand, is a methodological field.
>
> (Barthes 1979, 74)

Barthes' ultimate picture of the reader and text involves interaction and invention:

> Why is the writerly our value? Because the goal of literary work (of literature as work) is to make the reader no longer a consumer, but a producer of the text. Our literature is characterized by the

pitiless divorce which the literary institution maintains between the producer of the text and its user, author and its reader. This reader is thereby plunged into a kind of idleness – he is intransitive; he is ... *serious*: instead of functioning himself, instead of gaining access to the magic of the signifier, to the pleasure of writing, he is left with no more than the poor freedom either to accept or reject the text: reading is nothing more than a *referendum*. Opposite the writerly text, then, is its countervalue, its negative, reactive value: what can be read, but not written: the *readerly*. We call any readerly text a classic text.

<div align="right">(Barthes 1974, 4)</div>

Perhaps Barthes is right, though I suggest in the next section that there are two ways (at least) of interpreting and experiencing works of art. One may be like the Barthean interaction in which one may use a work of art and learn from it, whereas in another approach to works of art we cultivate the virtues of being able to surrender to artworks, enabling them to have an independent life.

Before moving to clarify such a distinction, it is worth noting that the Barthean model may especially fit the way some religious texts are read, historically and today. To take just one example, traditional Christians believe that the word of God is living and active. This means that the meaning of the Bible may unfold gradually over time and that the meaning of Biblical narratives and Christ's parables and teachings can come to have different facets over time. The meaning of the story of Joseph being sold into slavery in Genesis may be read as a harbinger of the life and sacrifice of the American civil rights leader Martin Luther King, Jr (Genesis 37:19, 20). One of the reasons why the Bible has this fluidity goes back to the treatment of intentionality. If God exists and intends to use scriptures as the locus of divine disclosure this may be pictured in terms of scripture being a fixed repository of wisdom. On the other hand, scripture may be pictured as a resource that can have a dynamic interplay between the church

and scripture in the context of God's dynamic interplay with the world. (If you find such issues interesting, check out *Philosophy of Religion: A Beginner's Guide*.)

Virtue aesthetics

Questions about the meaning of artwork inevitably bring up questions of value. To see this connection it may be useful to reflect briefly on one of the most aesthetically oriented philosophies of art in the twentieth century. John Dewey believed that we tend to group or identify the many events in our lives in relation to what we value. He offers this vivid understanding of when we might claim to have an experience:

> Experience in this vital sense is defined by those situations and episodes that we spontaneously refer to as being 'real experiences'; those things of which we say in recalling them, 'that *was* an experience'. It may have been something of tremendous importance – a quarrel with one who was once an intimate, a catastrophe finally averted by a hair's breadth. Or it may have been something that in comparison was slight – and which perhaps because of its very slightness illustrates all the better what it is to be an experience. There is that meal in a Paris restaurant of which one says 'that was an experience'. It stands out as an enduring memorial of what food may be. Then there is that storm one went through in crossing the Atlantic – the storm that seemed in its fury, as it was experienced, to sum up in itself all that a storm can be, complete in itself, standing out because marked out from what went before and what came after.
>
> (Dewey 1996, 612)

Dewey went on to claim that works of art are a product or artifact of such experiences; in works of art we set up an object that

(when experienced appreciably) invites or stimulates us to enjoy (or endure) a value-laded aesthetic experience.

One of the implications of Dewey's philosophy of art is that works of art do not properly function as works of art unless they are experienced. (If we invent a parallel question to 'If a tree falls in the forest and no one is around, does it make a noise?' and get 'If works of art are not experienced aesthetically, are they still functioning as works of art?', Dewey would answer the second question with a 'no'.) A further implication of Dewey's philosophy is that the very nature and meaning of aesthetics and artwork involve values, and so it is to values and works of art we turn in the next chapter.

In the next chapter we will consider a host of values to be found in works of art and that may define judgments of worth and excellence. In the present context of determining the work's meaning, however, values are not out of place. It seems that searching for a work's meaning involves a host of virtues: persistent observation, reading and re-reading, adroit listening, care, thoroughness, fairness, humility. Educational background seems to be key for some works of art but not for others. An important distinction lies in the difference between two phrases: *getting something from a work of art* and *seeing something in a work of art*. In the former, one may gain an insight from a work of art that was not intended by the artist nor determined by the historical conditions of the art-making. On this plane, the work of art may have a free-standing role in prompting one's aesthetic experience. This seems especially fitting when one takes seriously the aesthetic, affective dimensions of a work of art. In this approach to a work of art the virtue of persistent, sensitive observation may be less fettered by matters of meaning. You might learn something about jealousy from the play *Othello* quite independent of whether Shakespeare or his contemporaries would have been able to grasp your insights. We might say that *Othello* helped you develop a quite independent way of thinking.

In contrast, the idea of seeing something *in* a work of art suggests that there is a meaning of the work quite independent of whether you happen to see it. Perhaps the meaning is determined by authorial intent, history, cultural context, gender, and so on. But in this view, the work has this meaning and it falls to us to discover it. While on this model, one's observations may be guided by artistic intent, we can appreciate that it may also be informed by the work itself. Harold Osborne describes this as follows:

> The concentration of attention on the work of art as a thing in its own right, an artifact with standards and functions of its own, and not an instrument made to further purposes which could equally be promoted otherwise than by art objects . . . A work of art, it is now held, is in concept an artifact made for the purpose of being appreciated in the special mode of aesthetic contemplation; and although particular works of art may be intended to do other things and may in fact serve other purposes as well as this, the excellence of any work of art *as art* is assessed in terms of its suitability for such contemplation. This is what is meant by claiming that art is autonomous: it is not assessed by external standards applicable elsewhere, but by standards of its own.
>
> (Osborne 1970, 262–3)

Osborne's vantage point can be appreciated without going all the way back to the Beardsley-Wimsatt strict prohibitions on recourse to intentionality. The point I want to stress here about seeing something *in* a work of art (or hearing or feeling) is that it involves the virtue of attending to the work on its own terms, allowing the work to work on you as opposed to having the artwork stimulate you into independent reverie.

Given that artworks themselves are bearers of aesthetic properties, attentive observation involves an appreciation of *sensory* experience within the work as opposed to what is merely

associated with the work. Charles Hartshorne's understanding of emotions and colors seems to accurately reflect true lived experience of gazing at and into the artwork's different layers:

> The 'affective' tonality, the aesthetic or tertiary quality, usually supposed to be merely 'associated with' a sensory quality is, in part at least, identical with the quality, one with its nature or essence. Thus, the 'gaiety' of yellow (the peculiar highly specific gaiety) is the yellowness of the yellow.
>
> (Hartshorne 1968, 7)

C.S. Lewis ably described the process of seeking to experience artwork rather than, as he put it, using artwork. In *An Experiment in Criticism* Lewis wrote about the difference between using and appreciating an artwork:

> This attitude, which was once my own, might almost be defined as 'using' pictures. While you retain this attitude you treat the pictures – or rather a hasty and unconscious selection of elements in the picture – as a self-starter for certain imaginative and emotional activities of your own. In other words, you 'do things with it'. You don't lay yourself open to what it, by being in its totality precisely the thing it is, can do to you ... Real appreciation demands the opposite process. We must not let loose our own subjectivity upon the pictures and make them its vehicles. We must begin by laying aside as completely as we can all our own preconceptions, interests, and associations. We must make room for Botticelli's Mars and Venus, or Cimabue's Crucifixion, by emptying out our own. After the negative effort, the positive. We must use our eyes. We must look, and go on looking till we have certainly seen exactly what is there. We sit down before the picture in order to have something done to us, not that we may do things with it. The first demand any work of art makes upon us is surrender. Look. Listen. Receive. Get

yourself out of the way. (There is no good asking first whether the work before you deserves such a surrender, for until you have surrendered you cannot possibly find out.)

(Lewis 2006, 16–19)

This kind of appreciation involves what many consider aesthetic virtues, those qualities that enhance an experience of the aesthetic. If Lewis is right, these virtues involve active observation as well as a yielding surrender.

Some conceptual works of art are especially good at offering you both *something to see into* as well as something to impact one's *further reflection and seeing*. Consider, for example, these three images from the American artist Jil Evans' series *Prospero's Branch* (Figure 6). These are solar plate etchings made from digital images, capturing shadows randomly photographed as they move across the artist's sketchbook. The images seem alive and invite us to entertain the difference between a controlled frame (the sketchbook, which is always at the center), and the random air currents and ambient light. One can see in this work an artist's challenge to us to consider the natural response of the mind to look for meaning and metaphor. In a sense, what is *in* the work is a prompt to think *about* mind and meaning. The title recalls the magician in Shakespeare's *The Tempest*, who used his book

Figure 6 Jil Evans, selections from *Prospero's Branch* (2006), solar plate etchings (photo © Jil Evans).

of spells to magically create shapes and (with the help of Ariel) bring about peace, romance, and reconciliation.

So, what do artworks mean? There are some reasons to take seriously the presumed intentions behind the work, but we can also seek meaning in the work and its expressive properties in terms of history, culture, and its content in terms of gender and value.

4

What makes good art?

What makes a successful work of art? Why is a painting by Frida Kahlo or a novel by Virginia Woolf outstanding? A host of factors come into play involving imagination and creativity, communicability and expression, and more.

Imagination and creativity

Of all the values one may find in works of art, the creative imagination seems the most salient. Describing art such as Kahlo's paintings or Woolf's novels as creative and imaginative appears to be high praise. Defining exactly what the imagination and creativity are, however, isn't easy. One of the most common definitions of the imagination in modern philosophy is that it involves the power of imaging or making images. On this definition imagination can play a role in ordinary perception, as when one imagines or possesses an image of objects not wholly evident in sensation. What enables a person to say she sees a baseball rather than merely the surface of a baseball is that she imagines the ball as a whole object. Philosophical work on the imagination is complex and controversial. There are serious opponents to the idea that we have any mental images at all, even in dreams. But in the present context, let us at least grant some credence to the idea that it is the imagination that enables us to understand and represent the world as extending beyond what

we immediately sense or perceive (for elaboration and analysis, see Taliaferro and Evans 2011).

A further definition of the imagination is that it involves a power to grasp values. Some of what enables this grasp of value through imagination (in line with the British Romantic poets Wordsworth and Coleridge) is the result of our being able to see the world from other people's points of view. Woolf's psychological novels seem particularly adept at taking readers through multiple, successive personalities and states of consciousness. In *To the Lighthouse* we come to see a family and group of friends with all their vulnerability, love, vanity, and insecurity. Iris Murdoch underscores the role of the imagination in moral reflection:

> We may identify with deprived or persecuted people through our imaginative understanding of their plight. Such understanding is an instance of moral knowledge. How much do we know, what do we know, about 'what it is like to be' other people? As moralists, as political moralists, we specialise, we have favourites. We sympathise with, know about, some sufferers not others, we imagine and desire some states of affairs not others.
>
> (Murdoch 1992, 391)

Murdoch's highlighting the important role of imagination in filling out our moral sensibility is in line with what was noted about Balzac in Chapter 2: being detached from ourselves allows us to aesthetically explore the lives of others. C.S. Lewis articulates the way in which the imaginative reading of imaginative books helps us to transcend our narrow points of view:

> Each of us by nature sees the whole world from one point of view with a perspective and a selectiveness peculiar to himself . . . But we want to see with other eyes, to imagine with other imaginations, to feel with other hearts, as well as with our

own ... We demand windows. Literature as Logos is a series of windows, even of doors. One of the things we feel after reading a great work is 'I have got out'. Or from another point of view, 'I have got in'; pierced the shell of some other monad and discovered what it is like inside.

(Lewis 1992, 137)

As for creativity, there is no current consensus as far as definitions are concerned, but there is an abiding tradition that creativity involves the power to see or make novel objects ('objects' understood broadly to involve sounds, thoughts, and so on, and not only concrete physical things) in a way that is not determined by rule-following. For Kant, such creativity was a distinctive feature of the genius. Creativity, like originality, may vary in its praise-worthiness depending on the context. You might be praised for your first creative painting, even though it is not original in the history of art and it is only original for you.

Imaginative creativity may mark a genuine value in a work of art and be evident in the invention of characters, landscapes, use of color and depth of field, agility in performances, boldness, drama, and so on for the many different genres of artwork. Imaginative creativity can be demonstrated in what we described as a Kantian framework (Chapter 3) without explicitly bringing in a historical, anchoring framework, but in assessing the overall value of a work of art, history is almost unavoidable. Even if one designed a Brillo box artwork after 1968 with no knowledge of Andy Warhol's work, one's artwork would not be original. It would more likely be considered derivative or a critical appropriation.

'Creative originality' as a term may be too open-ended to name a basic good in artworks (there is nothing strictly incoherent about calling a work of art bad despite its originality and creativity), but it is at least a presumptive good.

Creative imagination is often highlighted in aesthetics in terms of artistic virtue or as observable qualities of works of art (for example, a work of art is describable as creative and imaginative), but it also needs to be appreciated that imagination is often needed for the reception of works of art. Being able to enjoy the play *Hamlet* requires not just watching and listening but being willing to believe that the actors playing Hamlet and Laertes engage in a duel, the character Hamlet dies of poison, and so on. This is sometimes described in terms of the willing suspension of disbelief. Some works of art are more demanding of their audience's powers of imagination: it is not hard to imagine you are witnessing a genuine car crash in an action movie if you are seeing it in 3D and the soundtrack is indistinguishable from an actual crash, whereas watching a puppet show requires more of a willing investment by the audience. Some philosophers have worried about how it is that we can come to have fears, love, and hate, in the context of fictional work. On the one hand, it seems that one can genuinely love the figure of Legolas in Tolkien's *The Lord of the Rings*, and fear for his safety, and yet one knows he is not a real character. One philosopher, Kendall Walton, has even proposed that we do not actually have fear and so on for fictional characters, but we have a kind of quasi-fear or imitation of fear, otherwise we would actively seek to come to the aid of threatened characters. This may seem quite counter-intuitive to those of us who have seen the shower scene in the 1960 Hitchcock film *Psycho*. Arguably we can truly be scared in our experience of film and other works of art and this is made possible through the creative imagination; a person is scared of the Bates Motel in *Psycho* when she comes to accept the fictional world as real.

Praise for creative originality is not limited to the west. In Indian aesthetics *pratibha* is the Sanskrit term for the creative disposition that enables poets to imbue their work with a power (*sakti*) that prompts wonder, enchantment, and engagement. While some sages or philosophers contend that *pratibha* can be cultivated by practice (it involves a *techne* one may follow), others

claim it is not governed by reason. Kalyan Sen Gupta seems to embrace both: 'In some people . . . *pratibha* flowers from the grace of God and of great men, but in others it flowers from proficiency and practice, and it is through this creative propensity that poetry comes into being' (Gupta 1996, 219). Whether learned or not, creative originality is an asset, in Indian, and not merely western, aesthetics.

The virtues of communication and expression

Works of art are appreciable not just for their being the outcome of the creative imagination, but for what they can tell us about the world, our emotions, values, the divine, and so on. The communication account of artwork we considered earlier in Tolstoy's philosophy of art may not be adequate to all artwork and performances, but it is pertinent to some. Artwork designed to advance a political, religious, scientific, ethical, or personal message may be assessed in terms of the clarity and success of the communication and the quality of the message. Some philosophers worry about whether some objects are artworks if all of the aesthetic components are completely subordinate to commercial or political messages. Be that as it may, some artworks do seem to function in a communicative fashion, and they can do so well or badly. Berys Gaut highlights the ways artworks can convey points of view:

> A painting is not just (or even) a beautiful object: it aims to convey complex thoughts and feelings about its subject, providing an individual perspective on the object represented. Thus it is that a painting not only can be a representation, but can also embody a way of thinking in an affectively charged way about its subject, and this perspective on its subject is an important object of our aesthetic interest in the work. So if a

painting does not succeed in meriting the responses prescribed,
it fails on a dimension of aesthetic excellence.

(Gaut 2008, 598)

Moreover, while the expressive or embodiment theory of art
may not work with all artworks, there is some reason to think
that works of art that express emotions in illuminating ways
have an excellence. In Rembrandt's painting of Lucretia the
expression or embodiment of poignant sadness, courage, and
despair is profoundly excellent.

Good communicability and expressiveness (like creative orig-
inality) may be only presumptive goods. Someone may be quite
effective in sending his message or exhibiting emotion but the
message is itself defective (unintentionally incoherent) or so
overwhelms the aesthetic that the work is more like a political
ad, a work of propaganda, than a work of art and the expression
of emotion may be so obtuse that, rather than an artwork, there
is merely a rant.

Communicability and expressiveness recall the relevance of
intentions behind some artwork. Success in meeting intentions
seems to count positively in assessing some works. The fact that
Kahlo successfully achieved her goal of employing elements of
local, Mexican popular art in exploring her dual European and
indigenous Mexican identity and Virginia Woolf was able to
advance her theory of androgynous personality in the novel *To the
Lighthouse* count as serious merits. A work of art might still have
great merit if it fails to fulfill an artist's intent. A film about war
might still succeed in terms of drama and direction even if it fails
to be the anti-war film that the director, actors, film crew, and
screenplay writers intended. (Arguably the 1979 American movie
Apocalypse Now is a superb film even if the anti-war message
intended by director Francis Ford Coppola was not crystal clear.)
Even so, a successful matching of intent and outcome may be
seen as a merit.

Intentionality can also come into play in terms of performance. In *Apocalypse Now* is the scene of Willard (played by Martin Sheen) in the hotel brilliantly acted? The main character appears to have done excellently in acting drunk and smashing a mirror with real glass. But it's not clear he was acting; Sheen was drunk at the time and, after punching the mirror, began crying and sought to attack Coppola. Or imagine a scene in *Hamlet* when it appears that Hamlet flies into a compellingly realistic rage at Polonius, but imagine that rather than acting, the person playing Hamlet lost all control and was simply giving in to his bitter anti-Semitism as he directed his rage at the Jewish actor playing Polonius. Of course we are rarely privileged (or cursed?) in knowing the inner intentions of performers or artists, but they can be relevant. It is difficult to admire Fellini as a director for his cinematic portrayal of a hand being cut off in the film *Satyricon* when you realize that this was not acting: a hand was actually cut off. There was no intention to simulate the mutilation. A final illustration may secure the relevance of intentions in assessing a work of art. Is the Beatles song 'Lucy in the Sky with Diamonds' from the album *Sergeant Pepper's Lonely Hearts Club Band* a brilliant song about LSD? It has certainly been interpreted that way, but if its writer John Lennon is right, the title came from a drawing his son made of his friend Lucy and was not about LSD at all. The song is still terrific, but the song is not about LSD and thus not a success in terms of satisfying artistic intent when the song was adopted by users of LSD.

Truths in works of art

Works of art may be commended for what they reveal truly about the world and values. Some works of art seem to require us to come to terms with their truth or reliability. Is James Boswell's *Life of Samuel Johnson* trustworthy? Its merit need not be seen

solely in terms of reliability, but part of its value may be seen in the extent to which it provides a portal on late eighteenth-century European life in the company of Samuel Johnson. Can we learn something of Russian life during the Napoleonic era by studying Leo Tolstoy's *War and Peace*? Some works of art comprise alternative worlds quite remote from our own, but they still have to have some traceable connection with our world. As Eddy Zemach writes:

> No writer, fantasy writers included, can forgo borrowing from reality. An utterly fictitious work will be too enormous to write; if it is given us by aliens we shall find it irrelevant and boring. An artist's target world may differ from reality in detail, but not in basic features: the kind of beings in it, their beliefs and desires, what motivates them, the emotions they have, and most laws of nature, cannot but be those that occur in [our world]. Now if a work has considerable aesthetic value, its world ... is well organized; it is unified yet variegated, revealing a new, exciting kind of unity in a multifarious world ... An author is a world-sculptor, who mostly works on borrowed material. We, who are that material, are keenly interested in what is done with it, for the features salient in the target world may fashion our own life.
>
> (Zemach 1995, 438)

So, many great works of fantasy can still offer portraits of life that we can access for credibility or illumination. J.R.R. Tolkien's *Lord of the Rings* can and does offer an understanding of the heroic quest and goodness that we may or may not find helpful. We may also see how Tolkien drew on his experiences in World War I to offer us a fantastic tour of what he called Middle Earth.

It would be wrong to hold that if a work of art seems to be built on or expresses a false view of the world, it is thereby a failure. Take two highly successful, radically different works: Dante's *Divine Comedy* and Camus' *The Plague*. Both visions of

life cannot be true. Dante's cosmic vision is full of divine light and concludes with an ecstatic vision of the love that made and sustains the cosmos. Camus' world is without God or cosmic purpose. Instead of an ecstatic vision of love, we are presented with the brave, resilient portrait of a good physician determined to serve humanity notwithstanding the certainty of there being future plagues and calamities. While both works cannot be true or the full truth, both can offer deeply moving accounts of what reality is like if Christianity or atheism respectively are true. So, while we should not think a work of art that has a vision of reality has to be true or seem true to be recognized as excellent, it still appears that one of the features of a work of art that is of genuine value includes assessing whether the work aids us in seeking out the truth – the truth about ourselves and others. *To Kill a Mockingbird* is good, in part, because it unmasks some of the ugliness of racism. One of the features that make Francisco Goya's painting *The Third of May 1808* outstanding is that it compels us to come to terms with the awful truths about warfare (see Figure 7). Artwork can (as Aristotle once contended in defending the value of tragedy against Plato's objections) have a cathartic, purifying impact that helps clarify our moral judgments.

Perhaps it is because we take truth to be an important value in artworks that we tend not to approve of or delight in forgeries.

Hans van Meegeren (1889–1947) is among the most famous art forgers of the twentieth century. In 1945 he confessed that he was responsible for six paintings that were sold as paintings by the great seventeenth-century Dutch painter Johannes Vermeer and two by the lesser-known, but prolific Dutch artist Romeyn de Hooghe. His confession was prompted by his desire not to be charged with being a Nazi collaborator. One of his fake Vermeer paintings was discovered in the art collection of Reichsmarschall Hermann Göring. If it had been a genuine Vermeer, van Meegeren would have been

guilty of selling Dutch cultural products to Nazis. By confessing that Göring's painting was a forgery, he avoided being branded a collaborator, but he was instead found guilty on charges of fraud and falsification.

Some forgeries do have extraordinary merit as copies or as original works that are in the style of other artists. From what we have called (in Chapter 2) a Kantian perspective of the origin of a work of art, forgeries would not be problematic. The problem with forgeries, however, is that the forged work is itself a kind of lie, a pretense or deceptive simulation. Even if the forgery is never detected it seems that the work is as defective as a so-called friendship in which the friend engages in

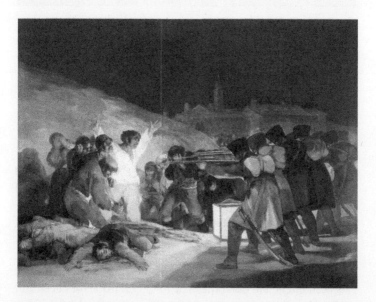

Figure 7 Francisco de Goya, *The Third of May 1808* (1814), oil on canvas, Museo del Prado (photo: Wikimedia Commons).

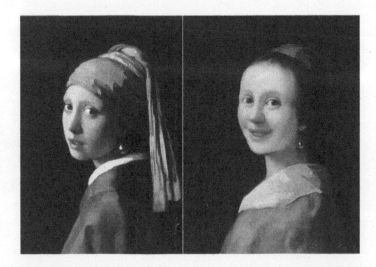

Figure 8 Left: Johannes Vermeer, *Girl with a Pearl Earring* (c.1665), oil on canvas, Mauitshuis, The Hague (photo: Wikimedia Commons). Right: Hans van Meegeren, *Smiling Girl* (c.1925), oil on canvas, National Gallery of Art, Washington, DC (photo: Image courtesy of the Board of Trustees, National Gallery of Art, Washington).

undetected systematic lying. See, for example, Figure 8, which sets a true masterpiece by Johannes Vermeer against a forgery by Hans van Meegeren, who forged Vermeer's work during World War II (van Meegeren was eventually caught in 1945, but died in 1947).

The case of forgery needs to be distinguished from cases of copying, as in China when copying works of art is done out of esteem and to maintain high cultural and individual artistic standards. In this case, the Chinese copy is much like a forgery except in intent and outcome. The forgery is made for deceit and profit. The Chinese copy is made out of respect for the true value of the original.

Also under the category of truth and art, we need to take seriously the claim that works of art may contain or possess truths that cannot be put into words. Perhaps this is true in the case of great paintings, sculpture, photographs, and architecture, but it is most often claimed by philosophers in the case of music. Consider two claims to this effect, the first by Susanne Langer and the second by John Dewey:

> It seems peculiarly difficult for our literal minds to grasp the idea that anything can be known which cannot be named ... But this ... is really the strength of musical expressiveness: that music articulates the forms that language cannot set forth ... The imagination that responds to music is personal and associative and logical, tinged with affect, tinged with bodily rhythm, tinged with dream, but concerned with a wealth of formulations for its wealth of wordless knowledge.
>
> (Langer 1942, 198, 207)

> If all meanings could be adequately expressed by words, the [art of] music would not exist. There are values and meanings that can be expressed only by immediately ... audible qualities, and to ask what they mean in the sense of something that can be put into words is to deny their distinctive existence.
>
> (Dewey 1934, 74)

If Langer and Dewey are correct, instrumental music may give us access to emotions and insights that resist translation into language. A plausible example of truth being embedded and displayed musically is the second movement of Samuel Barber's Adagio for Strings (Opus 11), from the 1930s. One may describe the music as mournful or consoling, but such terms hardly do justice to its meaning which (possibly) you may only grasp by listening to it.

Art, good, and evil

Works of art that seem to embody or reflect authentic values have some merit over those that do not. The Nazi propaganda film, *Triumph of the Will*, may be a brilliant film with creative, original cinematic effects, and a clear communication of truly Nazi aims, but don't we want to qualify our praise – for example, 'Oh, it's a film valorizing Hitler (who turns out to be a bloodthirsty genocidal maniac responsible for millions of deaths), but it's still a great film'? However you assess the aesthetic merits of artwork in the service of evil empires, it seems we do in fact praise works of art for enlarging our understanding of ethical values. The novels of Jane Austen help us in understanding pride and prejudice, sense and sensibility, power and humility, condescending usury and genuine charity. Charles Dickens' novels offer a kind of non-aristocratic, democratic aesthetic as we come to see beauty and worth in 'ordinary people', notwithstanding the horrible impersonal conditions of the industrial revolution.

A famous case of when ethics and aesthetics seem to clash is the German film *Triumph of the Will* (released in 1935) made by Leni Riefenstahl (1902–2003). The black and white film opens with majestic clouds and an overview of the city of Nuremberg as the plane carrying Adolf Hitler slowly descends and Hitler is given an ecstatic welcome as the great leader of a restored Germany after the humiliation of its loss in the last war. The film includes music by Richard Wagner (his *Die Meistersinger von Nürnberg*) and masterful editing that captures the energy of the Nuremberg Rally. The film was commissioned by Hitler himself and it has been recognized as one of the most extraordinary propaganda films of the twentieth century. In 2003, *The Economist* reported that *Triumph of the Will* made Riefenstahl 'the greatest female filmmaker of the twentieth century'. Maybe that is quite accurate, but some philosophers wonder whether such greatness in creative originality and drama

isn't compromised by the fact that (at the time of directing the film) Riefenstahl was a self-identified, confirmed National Socialist and the film itself clearly promotes Nazi aims.

As noted in the treatment of imagination earlier, insofar as works of art enhance our ability to imaginatively and affectively appreciate the points of view of others, they can have a vital role in the formation of our own values – a role that can be played well or badly. On this point, we do well to appreciate two vexing matters. First, works of art can actually distract us from pressing moral matters. This is part of the postmodern critique of mid-twentieth-century abstract painting and minimalism. It has been claimed that these art movements distracted us from more vital, cultural, political, and moral concerns. Second, there is what some call the *new art history* in which some works of art are heavily interrogated for their pernicious effects. According to these critics, the art canon is rife with sexism and racism. In the anthology *The New Art History*, Margaret Iversen writes:

> Art is no longer regarded as part of the solution but as part of the problem, laden as it is with the ideological baggage of history be it bourgeois, racist or patriarchal. The new critical procedure . . . involves a . . . critique of visual imagery, from painting to pop videos . . . [in order to] lay bare the contradictions and prejudices beneath the smooth surface of the beautiful.
>
> (Iversen 1988, 84)

Let's linger further on ethics and art. Initially it seems that works of art can be commendable when you advance what seem to be (to the best of our knowledge) moral insights, and tarnished when they advance apparently beautiful but morally vicious messages. Some art critics and philosophers disagree. I.A. Richards, for example, maintains that when you read poetry in terms of ethics

(is the poetic vision fascist?) or even truth (does the poem enhance our understanding of the world?) you have ceased reading it as a poem. You are instead involved in ethical inquiry: 'We have for the moment ceased to be reading poetry and have become astronomers, or theologians, or moralists, persons engaged in a quite different activity' (Richards 1964, 277). The position that works of art constitute a realm independent of ethics has been called autonomism.

There does seem to be a danger if we give ethics too central a place in our philosophy of art. This seems especially the case when the ethical judgment of an artist prompts us to condemn his or her art as failures. Do we really want to denigrate the art of Picasso and Rodin on the grounds (apparently true) that both men were misogynist, or think ill of Wagner's works because he was anti-Semitic? Are the paintings of Gauguin in Tahiti worse or diminished because Gauguin abandoned his wife and children to go to Tahiti to paint? And it seems that if we relentlessly measure the success or failure of artworks in terms of their relationship to our status quo ethics, we risk falling into smugness and dogmatism. Michael Tanner has written on the importance of entertaining different, remote views of life and value as a way of challenging and expanding our point of view:

> Beginning with a view of life which is remote from theirs [ours], one might, thanks to the power they have to command our imaginations, gradually come to take up a series of different attitudes to phenomena with which one is familiar, as well as being introduced to others, and find that viewing the world from this new vantage point, or perspective, seems to give it more coherence, sense and therefore value.
>
> (Tanner 2003, 367)

The above points seem good. It is good for us to entertain different worldviews and systems of value. But some works of

art seem to directly address the observer's moral point of view (whether as a challenge or re-enforcement) and not merely endorse the entertaining of possibilities. Berys Gaut writes about how some works of art themselves seem to stand or fall in terms of whether they merit responses from viewers:

> Ethicism can be fully defended by appeal to those responses the reality of which is relatively uncontentious. For these include pleasure and displeasure, which are pervasive in our responses to fictions, and, as we noted, a person can be ethically criticized for what she takes pleasure or displeasure in. Someone who actually enjoys imagined suffering can properly be condemned for this response. Hence, pleasure and displeasure felt toward fictions are the only kinds of responses the reality of which one needs to appeal to in order to defend ethicism successfully.
>
> (Gaut 2003, 598)

Nöel Carroll agrees that some works – especially narrative artworks – seem to be essentially about moral judgments. If he and Gaut are right, some narrative poems need to be considered in terms of ethical values. Carroll argues, 'Moreover, contra autonomism, since narrative artworks are designed to enlist moral judgement and understanding, morally assessing such works in light of the quality of the moral experience they afford is appropriate. It is not a matter of going outside the work, but rather focusing right on it' (Carroll 2001, 293).

One way to support Carroll's point is to take seriously the difficulty of assessing narrative works that build into them wildly divergent moral convictions. Kendall Walton sets up the problem with these questions:

> Can an author simply stipulate in the text of a story what moral principles apply in the fictional world, just as she specifies what actions characters perform? If the text includes the sentence,

'in killing her baby, Giselda did the right thing; after all, it was a girl' or 'The village elders did their duty before God by forcing the widow onto her husband's funeral pyre', are readers obliged to accept it as fictional that, in doing what they did, Giselda or the elders behaved in morally proper ways? Why shouldn't storytellers be allowed to experiment explicitly with words or morally different kinds, including ones even they regard as morally obnoxious? There is a science fiction; why not morality fiction?

(Walton 2003, 346)

Walton is skeptical about such a proposal.

In the spirit of Walton's questions, one way to test your own view is to consider the following: novels since the early twentieth century have sometimes employed what is called the misleading narrator, as opposed to the so-called omniscient narrator. An omniscient narrator may keep you in suspense, but he or she may be presumed to be accurate and reliable. The narrator, Holden, in J.D. Salinger's *The Catcher in the Rye*, on the other hand, cannot be fully trusted in his description of his life and the events that unfold. He may not lie to his readers but after a few chapters one begins to suspect his story is dodgy and Holden may be suffering from self-deception. Would you conclude that your narrator was misleading or omniscient if you came across a novel called *Child Care* that began: 'John and Jane took their newborn to the clinic to be skinned and salted. The day was particularly special because this wonderful act of painful cleansing purged the child of sin.' OK, maybe you would conclude the book was more a case of bad comedy but if the narrative went on to multiple volumes, you would probably think the narrator was sarcastic, misleading, insane, or simply wicked. If so, you have some reason to think that a work of art is tarnished or in some way compromised if its central message is the celebration of what seems evil.

Science and artwork

The relationship of science and art can raise a range of issues involving artistic merit. Science is often behind the development of the tools employed by artists, from the chemistry of paint to the optics and electronics of cameras, video recorders, and other digital equipment. The extent to which some artists make use of such equipment amounts to an appreciable positive value in the artwork. Art has also been employed in the advancement

Figure 9 *The Mobile Rain Garden Unit* (2010) is a mixed media sculpture and miniature ecosystem that showcases a thirty-minute documentary about a community effort to build a demonstration rain garden on the East Side of Saint Paul (photo © Christine Baeumler).

of science both cognitively and in terms of highlighting the concerns that arise in the scientific community. On the first point, early modern science was supported by collections and drawings amassed by artists as in the fieldwork and art of the Academy of Linceans, founded by Federico Cesi in 1603. This group encouraged and supported the work of Galileo. As for the second point, artists today, Christine Baeumler for one, are producing works that seek to mitigate environmental damage through aesthetic and ecological interventions. Baeumler works collaboratively with citizens, students, engineers, and ecologists to reclaim urban ecosystems by reconnecting participants and visitors to nature in their own neighborhoods through the revitalization of degraded green spaces. These ends or features can mark distinguishable important values in artwork.

A recent debate in science and art concerns the artistic implications of using a camera. In painting and drawing it appears that one may represent an object without the object being present. I can draw a picture of Hitler without the tyrant being present (see Figure 10). But to photograph Hitler, it seems you would have to actually get a shot of Hitler himself or perhaps take a photo of someone dressed up as Hitler. Does this reveal any deficiency in photography as opposed to the more traditional arts? Contemporary photography obviates this question as artists have

Figure 10 My drawing of Hitler.

been able to use photography in ways that employ the equivalency of brush strokes.

One philosopher, Kendall Walton, proposes that photography enables us to see the past, and not merely a remnant of past events:

> I must warn against watering down this suggestion, against taking it to be a colorful, or exaggerated, or not quite literal way of making relatively mundane point. I am not saying that the person looking at the dusty photographs has the *impression* of seeing his ancestors – in fact, he doesn't have the impression of seeing them 'in the flesh', with the unaided eye. I am not saying that photography *supplements* vision by helping us to discover things that we can't discover by seeing. Painted portraits and linguistic reports also supplement vision in this way. Nor is my point that what we see – photographs – are duplicates or doubles or *reproductions* of objects, or *substitutes* or *surrogates* for them. My claim is that we see, quite literally, our dead relatives themselves when we look at photographs of them.
>
> (Walton 2005, 79)

If Walton is right, one measure of excellence in a photograph may be its degree of transparency and access to the past.

Another debate that has arisen out of scientific advance concerns electronic and recorded music. Is there an aesthetic difference between music produced mechanically versus direct human agency – for example, a drum roll produced by Ringo Starr versus an electromechanical sound machine? When playing recorded music the song patterns are fixed and the only thing that might go wrong is your CD player might break. But in live music, it seems *anything* might happen. Does the live performance have more existential presence than recorded music? One philosopher of art, Walter Benjamin, contended that original traditional art had an 'aura' or essential essence that is lost in our technical age of reproducibility (as with reproducible photography). One can

have some sympathy with Benjamin's stance with respect to reproductions of original artworks such as paintings and sculpture. To see a reproduction of a Turner painting misses out on the physicality of the original. But it is hard to see that there is any diminishment of value in a photograph or film because of reproducibility.

The scientific invention of ways to reproduce works of art worried Walter Benjamin (1892–1940). Benjamin (pronounced Benyamen) was a German-Jewish Marxist philosopher and cultural theorist who, tragically, took his own life in France to resist being captured by the Nazis. Benjamin did not see art as an ahistorical practice like Kant, but as a deeply historical undertaking, very much shaped by politics, economics, and technology. When it comes to locating works of art, Benjamin thought that our age of reproduction (through photography, film, printing, print-making, recording, and so on) has overshadowed or eclipsed our sense of the 'presence' and reality of a unique work of art. Unique artworks have what Benjamin was prepared to call an 'aura', its particular qualities that reflect its historical and physical conditions and the practices that produced it. Mechanical reproductions can, in a sense, emancipate the work from its historical embeddedness, but we thereby also lose something valuable about the unique materiality of a work of art.

Religion and artwork

Because of the pervasiveness of religion and its use of art today and historically, it is worth noting that works of art may also have merit in religious terms. A remarkably high percentage of works of art throughout the world and over time may have merit from a religious point of view. For Christians, for example, virtually all domains of the arts have produced works deemed by many non-Christians to be excellent: literature (*The Divine Comedy*

or T.S. Eliot's *Four Quartets*), painting (the Sistine ceiling), music (Bach's Mass in B minor), sculpture (Michelangelo's *Pietà*), architecture (Chartres Cathedral), and so on. The same is true for art made in the service of the other world religions of Judaism, Islam, Hinduism, and Buddhism. Insofar as artwork helps embody or express the insights and practices of these traditions, they may be deemed to have great religious value. It is difficult even to conceive of Hinduism without taking into account the abundance of aesthetically rich images, from early cave engravings to temples and manuscript illustrations. For most Hindu philosophers, such images are believed to be of representations of the divine rather than unconditional displays of ultimate reality. They are nonetheless prized as vital for religious practices. From a Hindu point of view, then, a sculpture of Lord Shiva can be an important, vital display of divine energy as represented by dance (as noted in Chapter 3).

In the three monotheistic traditions, however, there has been strong resistance to image-making. Part of this is due to prohibitions against idolatry (treating something non-divine as divine) but it was also prohibited on the grounds of the transcendent 'otherness' of God. God is the uncreated, non-contingent, omnipresent reality who makes and sustains the cosmos and to represent God as an image threatens to undermine the radical difference between Creator and creature. Because Christians believe God to have become incarnate as a human being (Jesus Christ is both fully human and fully divine), they believe it is not just permissible but good to picture God iconographically. Still, it is worth pausing for a moment more and considering why religions might seek imageless worship and reverence.

Arguably, some image (or at least idea) of God is essential to love and worship God, just as some image or idea of someone or something is essential to loving and respecting that person or thing. If I have no idea whatever of your identity, it would be

difficult even to imagine loving you. That being said, images and ideas can stand in the way of love: what if my image or idea of you is wrong? Imagine I picture you as an aviator-poet whereas you hate flying and only like prose. In that case, perhaps I only love my image of you and not you yourself. In a loving relationship, presumably the images and ideas we have of one another are dynamic and ready to shift as the occasion calls for it, but might there also be a good found in a non-mediated presence or imageless state of mind before the beloved? This would be a state of mind with no work of art in the mind's eye but there still may be what the ancients and many would call 'art' today, such as the art of meditation.

Aesthetic values

Many other values might be found in works of art: art may bolster cultural and national identities, celebrate public service and honor, undermine the status quo, and so on. There are also at least three sorts of values to be noted that are distinctly aesthetic: aesthetic texture, the sublime, and the beautiful. These are among the most important and central to art criticism.

Aesthetic texture: how music, novels, and poetry sound, how a painting looks, and so on, in affective or emotive terms. Literature, painting, sculpture, and all the arts can display or embody aesthetic features. An important value can be seen in the way these features are interwoven. Does the instrumental music drown out and overwhelm the singing? If so, does this make for a better or worse performance? Does the size of the sculpture dwarf what appears to be the humility of its thematic content? Does the length of the film diminish its power? Does the play have distracting scenes that serve no purpose, not even comic relief or to set up an interesting red herring? Is the scene in the novel deeply moving in a way that involves a genuine lament

or is it sentimental, saccharine or unconvincing? The overall aesthetic impact of a work of art can be of great importance. We may well praise works of art for their dissonance, apparent incoherence, or absurdity (some of Kafka's work). But (as with anti-art art or anti-philosophy philosophy), there are limits. Lewis Carroll's *Alice in Wonderland* is a classic, highly successful fantasy because its child heroine is sane and (for the most part) good and innocent, but if Alice was as mad as the Queen of Hearts, all of the jokes about executing different characters by decapitation, etc., would lose their humor and puzzling/enigmatic/delightful enchantment. Because Alice keeps her head when all about her might lose theirs, we are enabled to entertain without fear the hysterical orders to decapitate people.

In Indian aesthetics the aesthetic or affective qualities of art are referred to as *rasa*. The term refers to fundamental human feelings such as delight, astonishment, anger, fear, heroism, laughter, and sorrow. These may variously enter into one's experience of art as marvelous, odious, erotic, comic, and so on. B.N. Goswami observes:

> A performance of dance or music or of a play might often be criticized as being devoid of *rasa (nirasa)*, or praised for yielding *rasa* in great measure. The voice of a singer would be acclaimed for being charged with *rasa (rasili)*, the eyes of the beloved would be described as filled with *rasa*, and so on.

> (Goswami 1996, 691)

Rasa comes very close to what we have been referring to in the book as the aesthetic: an appreciative experience of the affective properties of events and things. Goswami notes the similarity of *rasa* to tasting:

> [Yes], it is said that as taste [*rasa*] results from a combination of various spices, vegetables and other articles, so the durable emotional states [*shayibhava*], when they come together with

various other psychological states, attain the quality of a sentiment [that is, become sentiment]. Now one inquires, 'What is the meaning of the word *rasa*?' It is said in reply [that *rasa* is so called] because it is capable of being tasted. How is *rasa* tasted? [In reply] it is said that just as well-disposed persons while eating food cooked with many kinds of spices enjoy its taste, and attain pleasure and satisfaction, so the cultured people taste the durable emotional states while they see them represented by an expression of the various emotional states with words, gestures, and derive pleasure and satisfaction. Just as a connoisseur of cooked food [*bhakta*] while eating food which has been prepared from various spices and other articles tastes it, so the learned people taste in their heart [*manas*] the durable emotional states [such as love, sorrow, etc.] when they are represented by an expression of the emotional states with gestures. Hence, these durable emotional states in a drama are called sentiments.

(Goswami 1996, 694)

In the west as well as in Indian aesthetics, aesthetic texture can be a key element in an artwork's success or failure.

The sublime: The sublime is often contrasted with the beautiful and is most often used to refer to awesome greatness that inspires fear without endangering the observer. Kant describes the sublime in nature as follows:

Bold, overhanging . . . threatening rocks, thunder clouds piled up the vault of heaven, borne along with flashes and peals, volcanoes in all their violence of destruction, hurricanes leaving desolation in their track, the boundless ocean rising with rebellious force, the high waterfall of some mighty river . . . make our power of resistance of trifling moment in comparison with their might. But, provided that our own position is secure, their aspect is all the more attractive for its fearfulness.

(Kant 1964, 110)

Edmund Burke argued that the sublime was found in astonishment, a 'state of the soul in which all its motions are suspended with some degree of horror' (Burke 1856, 72). Another major source of the sublime is infinity:

> Greatness of dimension is a powerful cause of the sublime ... Infinity has a tendency to fill the mind with that sort of delightful horror which is the most genuine effect and truest test of the sublime. There are scarcely any things which can become the objects of our senses, that are really and in their own nature infinite; but the eye not being able to perceive the bounds of many things, they seem to be infinite, and they produce the same effects as if they were really so.
>
> (Burke 1856, 92)

While Burke thereby praises the sublime in the natural world, the sublime is also evident in works of art. According to Kant, Homeric poetry about Venus is beautiful, while Milton's depiction of hell is sublime with its arousing fearful horror. J.M.W. Turner's paintings of outrageous seas with ships amid titanic storms are often considered the gold standard when it comes to the sublime. In music, Mozart's *Requiem* is also a work that seems altogether sublime. According to Kant, the sublime often involves greatness and scale, whereas beauty can be humble and small. And if the sublime can be experienced by the infinite or the eye's belief that it is seeing the infinite, vast scenes of grandeur like Turner's would evoke both astonishment and fear.

Some philosophers today are wary of the sublime for it seems to involve ecstatic rapture without any essential reference to moral values. Perhaps it is so dangerous because the sublime marks one of the great merits of certain kinds of art and some of our experiences of the natural world.

Is a work of art defective if it is sentimental? Originally the term 'sentimental' was not derogatory; it meant (roughly) 'full of feeling' and to call a work sentimental was to identify it as something that truly engages the sentiments. More recently, however, some philosophers and art critics would put 'fabricated, self-indulgent feelings, and dishonesty' in the definition. Oscar Wilde famously described sentimentality as having emotions you are not willing to pay for. A sentimental film may make one feel manipulated, given over to pleasure or tears in response to what seems like a false happy ending or a melodramatic failure which, from the point of view of real tragedy, does not merit real sorrow. However, sentimentality does have its defenders. It has been argued that some clearly sentimental artwork, such as Charles Dickens' *A Christmas Carol*, is based on a false view of the poor and privileged and it contains an unlikely, even miraculous (yet full of sentiment) conversion of Scrooge, and yet the play delivers a badly needed, important message about love.

Beauty: Some important, highly valued works of art seem profoundly unbeautiful. The portraits of some figures by the painter Francis Bacon seem rife with terrifying torment. Given a narrow definition of beauty where beauty is equated with harmony, pleasing symmetry, and sweetness, very little contemporary art in all genres seem beautiful. But as we saw in Chapter 1, beauty can be understood as a fitting or proper pleasure or aesthetic delight. In this broader category, one may well rank the values of works of art or events or objects in general on the extent to which they arouse intrinsically appreciative aesthetic delight or pleasure. From one point of view, Francis Bacon's subjects may indeed be ugly, but isn't the overall effect (his masterful command of color and form, the close study of piercing expressive raw emotion) something we aesthetically prize and find mesmerizing? Paradoxically, sometimes the ugly or horrifying can be so framed

that we deeply value (and so, in a sense, find beautiful) the work of art as a whole.

As a term, 'beauty' does not enjoy a conspicuous, dominant place in contemporary art criticism, though it is making a comeback (inspired by Iris Murdoch; see Elaine Scarry's book *On Beauty and Being Just*). However, its lack of explicit use is not evidence that matters of beauty are sidelined. Calling a work of art beautiful amounts to claiming it is worthy of appreciable observation (engagement or overall enjoyment), but this in and of itself does not specify why the object is worthy of such attention. Criticism, then, comes to the fore. It spends little time reflecting on whether artwork is worthy of attention and dives right into why or why not some of the features of the artworks do succeed or fail in the work as a whole. Matters of beauty, however, may still be in the background. The reason why the art critic is focusing on the work at all is because it is beautiful.

So, what makes artwork good? Artistic merit seems a matter of many factors including imaginative creativity, the virtues of communication and expression, truths in works of art, judgments of good and evil, possible religious and scientific value, and the distinctive goods of aesthetic texture, the sublime, and the beautiful.

5

The location, ownership, and dangers of works of art

Artworks raise interesting, unique questions about their identity, ownership, and control.

Locating works of art

Locating some works of art, especially original sculpture, seems unproblematic. Leonardo da vinci's *Mona Lisa* is in the Louvre in Paris and Michelangelo's *David* is in Florence. But matters differ when works of art are replicable or can be performed. When you photograph X, what is the work of art? The negative (if you are using film), the first print, or any number of prints or the one you designate as authoritative? In photography and print-making, authorial intent seems a reliable standard (when available) to authoritatively specify what stands out as the proper artwork. But consider poetry.

T.S. Eliot wrote the poem 'The Love Song of J. Alfred Prufrock' some time between 1910 and its publication in 1915. It begins:

Let us go then, you and I
When the evening is spread out against the sky

> Like a patient etherized upon a table;
> Let us go, through certain half-deserted streets,
> The muttering retreats
> Of restless nights in one-night cheap hotels
> And sawdust restaurants with oyster-shells:
> Streets that follow like a tedious argument
> Of insidious intent
> To lead you to an overwhelming question ...
> Oh, do not ask, 'What is it?'
> Let us go and make our visit ...
>
> (Eliot 1998, 5–6)

Could someone else have written the poem? Might it have been the case that Eliot did not write it at all, but might someone else have written it? This seems imaginable. It also seems possible that someone might have made up this poem in 1905, written it down, never published it, and yet Eliot quite independently wrote his poem. In short, there appears to be a contingency in this case between the artist and the work of art. Arguably, the work of art itself appears not to be identical with the scrap of paper upon which the original was written for even if that were destroyed the poem would still exist. In fact, it seems to be imaginable that all written versions of the poem in all languages might cease to be and the poem would still endure: many of us have memorized the poem and, at one point in my life, I could write it out for you without error. Although we may hesitate in this further thought experiment, perhaps the poem would still endure if everyone forgot it and all memory vanished, for even under those circumstances I think we would want to say that (from a God's eye point of view) if someone in the year 2020 came up with a poem: 'Let us go then, you and I ... ' under the title, 'The Love Song of J. Alfred Prufrock', the poem had been rediscovered. If we do want to go this far in our view of art, then some works of art (poems, plays, novels, stories, musical

works) are abstract objects as opposed to concrete individual things.

As abstract objects, poems, plays, and musical compositions can function as reference points to describe performances. If Shakespeare's play *Hamlet* is the abstract object replete with all the details designated by Shakespeare as *Hamlet*, then a radical deviation of the plot (in your play, Hamlet and Ophelia marry and live happily ever after) means you are not performing *Hamlet* and probably not even offering a version of *Hamlet*. And yet, so long as you comport with what Shakespeare identified, you may take abundant liberties, setting the play in a modern city or dress the players in Victorian clothes, and so on.

Thinking and speaking of some artworks as abstract objects seems bolstered by our whole approach to performance. After all, we speak of a work (a play, for example) as existing prior to a given performance and then, though the performance has ended, we speak as though the work is enduring.

Identifying works of art as abstract objects therefore seems plausible, but it does have its detractors. Some worry that such a view relegates artists to being discoverers rather than creators. If someone other than Eliot could have written 'The Love Song of J. Alfred Prufrock' then it seems Eliot discovered it first. Jerrold Levinson advances a precept that explicitly rules out the possibility of a musical piece existing prior to its composition: 'Musical works must be such that they do *not* exist prior to the composer's compositional activity, but are *brought into* existence *by* that activity' (Levinson 1980, 9).

One cannot help admiring Levinson's giving a pivotal role to the artist-composer, but he still faces the somewhat counter-intuitive result that it would make no sense to claim that a musical work might have been made earlier. Perhaps he can maintain that such a thesis makes sense once the musical work is composed – that is, after Mozart has composed a mass, it makes sense to say of *that* piece that someone else might have created (discovered?)

it earlier. In any case, Levinson raises two additional points that seem to secure a high role for artists.

Some art critics and philosophers employ a strict distinction between works of art themselves and performances. One cannot perform Beethoven's Piano Concerto in E flat major (Opus 73) on the electric guitar. But one can use an electric guitar to do an interpretation of the musical composition. Allowing that compositions, scripts, poems, and other works of art have substantial limits that govern performances, need not lead one to utterly subordinate performances to the work of art itself. There are interesting differences in the Harry Potter films between Albus Dumbledore as played by Richard Harris and then by Michael Gambon, and some performances have been so distinguished as to make enduring contributions of their own, such as Sir John Gielgud's Hamlet or, more recently, Sir Ian McKellen's Othello.

Levinson is in what we are calling the general Hegelian camp of identifying the meaning of works of art in light of their specific, historical setting. So, he believes that when Mozart or any composer identifies a musical work, she or he is thereby identifying sound structures with specific historical meaning of the time:

> Musical works must be such that composers composing in different musico-historical contexts who determine identical sound structures invariably compose distinct musical works.
>
> (Levinson 1980, 14)

The composer is also designating a means of performance:

> Musical works must be such that specific means of performance or sound production are integral to them.
>
> (Levinson 1980, 15)

Given such specificity, it may well be quite implausible to think that, for example, a mass by Mozart could have been written by someone else, twenty years later.

Whatever your final position on such matters, philosophers of art have often made a distinction between the aesthetic status of a poem, play, and so on, and its performance. Is there an aesthetically relevant difference between a live performance and the re-playing of that performance on a recorded device? There are reasons for thinking so. I suggest there is. In general, live performances can express the influence not just of the performers but of those present (in any number of ways). Moreover (as pointed out in Chapter 4), in a recording, the only real failure you might observe or hear (unless the recording is of a failed concert or play or poetry reading . . .) is a failure in the sound system. In a live performance, however, there is always the possibility of failure and sometimes the opportunity to achieve a new level of aesthetic excellence.

Ownership of art

In some respects, the ownership of art raises no more (or no fewer) philosophical puzzles than owning any artifact. You may pay an artist to paint your portrait and pay a carpenter to make you a bed, and the transaction is straightforward. Special issues come up, however, in several areas: the limits of appropriation of the work of one artist by another (or the difference between copying and creatively responding to another's work); control over the reproduction of the artwork, the right to benefit economically from his or her art; the right of an artist to prevent her works of art from being mutilated or destroyed; the right of nations or communities to assert ownership over works of art as part of their identity; and the concept of stolen art.

Appropriation of works of art by other artists has been a vexing concern in recent years, but in some respects the practice of some kind of appropriation has been commonplace in the history of art. We might prefer to call this links in a chain of inspiration: Virgil was inspired by Homer, Dante was inspired by Virgil, James Joyce was responding to Homer, and Picasso was painting in reply to Velásquez, but there is some appropriation involved as well. There are clear cases of forgery (van Meegeren forged paintings he attributed to Vermeer) and legitimated cases of when one artist learns from another (Virgil and company) and problem cases that are probably best resolved in copyright law rather than in a book on aesthetics. The other matters also are probably best settled by convention but they do involve the philosophy of property, as when someone who owns your painting may seek to use a photograph of it for commercial purposes, without your consent. Today, there is vexing controversy over the way music may be owned or copied in ways that do or do not respect composers and performers. We do well to realize that this is not a new problem. Throughout the history of music there has been a habitual practice of borrowing:

> This sort of compositional cannibalism was not at all uncommon in Handel's day. Indeed ... it would have been close to impossible to produce as much music as was required of the typical 18th century composer for the church, the crown, or the theater without digging into the back catalog a bit. This mode of musical production is consonant with the 'craftsman' role musicians and composers played in society at that time. Autonomous compositional originality (*inventio*) was not as important as the ability to produce appropriate music for specific occasions, events, and social contexts; if a melody from an earlier piece ends up regurgitated in a new context, then so be it. It's doubtful whether many listeners

(if any) would have even noticed – this was the day, after all, when music was only available through performance, and thus individual pieces would only have been heard a limited number of times.

(Wallmark 2010)

Any full philosophy of musical ownership will have to take account of the prevailing cultural assumptions of propriety and respect.

It is an interesting point to resolve in owning an artwork: do you also have free rights to make any use of it at all? As for the question of national identity and when a work of art is stolen, there are clear cases. When the Germans occupied France in World War II and confiscated French masterpieces, these were stolen objects requiring a return to France. Probably the most famous difficult case, however, in terms of propriety, concerns the sculptures from the Parthenon that were removed from Greece by Lord Elgin and are now on display in the British Museum. Consider Daniel Shapiro's overview on the current state of play concerning the sculptures:

> Without question, they belong to and are part of Greece's identity and inalienable heritage, and are universally recognized as such, including in their display at the British Museum. But for some, Greek and non-Greek alike, the recognition that the Parthenon's sculptures are Greek is not enough. Their return to Greece is sought, even though they can no longer be affixed to the Parthenon and, as in London, should be housed in a museum. Yet, for those who seek their return, their absence is a loss that is believed to diminish Greece and prevent the sculptures from being fully appreciated or understood. For others, what Elgin did, if otherwise questionable, at least saved the sculptures from destruction by the Turks, Greek lime kilns, and other disasters, and preserved them as part of all humanity's heritage,

resulting in increased appreciation and understanding of ancient Greece.

(Shapiro 1998, 121)

Matters of ownership have arisen with respect to ethnicity. Is there an *essence* to what may be called African Art? Is what may be called indigenous African art more authentically African than artwork that is influenced by Europeans? What about what has been called 'tourist art', objects made to be sold to the Portuguese and other Europeans? Questions about authentic African art come to the fore in debates over whether European artists in the twentieth century exploited African artworks.

In the early twentieth century, European artists such as Pablo Picasso and Henri Matisse made use of African imagery in their paintings. Was this a benign, perhaps immensely positive and inspiring use or was this a form of European colonization/colonialism? While some art historians assume the latter, consider the following depiction of Picasso's response to African artifacts, as related by André Malraux:

'I stayed. I stayed.' He felt that 'something was happening [to him] ... that it was very important.' He suddenly realized 'why he was a painter.' For unlike Derain, Matisse, and Braque, for whom 'fetishes', '*les negres*', were simply 'good sculptures ... like any other', he had discovered that these masks were first of all 'magical things', 'mediators', 'intercessors' between man and the obscure forces of evil, just as potent as the 'threatening spirits' present throughout the world, and 'tools' and 'weapons' with which to free oneself from the dangers and anxieties that burden humanity.

(Malraux 1974, 17)

Perhaps talk of 'magic' may strike one as an attribution of superstition, but arguably Picasso was responding to the aesthetic

power of African artwork. Even so, Picasso had little knowledge of the displayed African artifacts and one may build a case that it was problematic for him to rip such images completely from their context and address them in terms of what may well seem (from an African point of view) foreign values.

By way of a modest suggestion as to how to approach such questions of authentic African art, the current trend in African studies seems desirable: focus on smaller language groups such as the Yoruba (located in southwestern Nigeria, and one of the groups most studied by anthropologists and historians) rather than beginning with a pan-African point of view. It is probably best to begin with a more grass-roots approach to aesthetics and not to work with too sharp a divide between what is authentically African and what is not. After all, Africa today is forty per cent Christian and forty per cent Muslim, and while neither Christianity nor Islam originated in Africa, it would be problematic to think of Christian and Islamic African culture as foreign.

Caring for artwork

The care and treatment of works of art raise a host of philosophical issues, beginning with the challenge of formulating a clear understanding of works of art in relation to time. When a work of art begins to age, losing some of its color and definition, was this something intended by the artist? Some contemporary works of art are auto-destructive and intended not to last; arguably these should not be restored. But in cases when the artistic intention is not known, matters become more troubling. Art conservation can be minimal – shielding an artwork from dangerous light, temperature, and humidity – or it can involve more aggressive restoration such as repainting. Art conservation therefore involves difficult decisions about retaining the *substance*

or *material constitution* of the artwork (retaining Leonardo da Vinci's paint in the painting, the *Mona Lisa*) or retaining the *appearance* of the artwork (how the *Mona Lisa* would have looked to Leonardo and his contemporaries). Some philosophers think that artistic intentions should play no role whatever in making decisions on these matters: 'Even if [the artist] says explicitly how he desires the work to appear in the future, we need not necessarily accept his viewpoint. Just as the artist is not necessarily the best interpreter of his work, so he may not be the final authority on how it should be conserved' (Carrier 2009, 86).

An equally troubling problem area lies in the extent to which the meaning and nature of an artwork rests on its original, intended use and site. Consider an icon that was intended for use in church services, but is now displayed in a museum. Arguably, its function has changed from a religious context of worship, veneration, and petition, to being an object of aesthetic experience, an experience that may be utterly secular.

Some architectural structures that merit inclusion as great works of art are intentionally allowed to erode: ruins. There are two broad philosophies of ruins that are sometimes identified as the classical and romantic views. According to the classical model, the ruins of, say, a temple from Roman imperial times represents a remnant of some ideal or great age that is past. The ruin might even be partly repaired or there may be a model of the edifice available to assist viewers in imaginatively reconstructing what the temple or cathedral or abbey might have looked like at the height of its use. The romantic model, on the other hand, prompts us to consider the passage of time. There is something humbling about contemplating the remains of a great imperial age. The sentiment behind the romantic model is at work in J.R.R. Tolkien's book *The Hobbit* in the chapter 'Riddles in the Dark'. Gollum asks Bilbo what devours beasts, destroys stones and steel, beats down mountains, slays kings, and the like. The answer: 'Time!' A ruin can be an important place

to reflect on the erosion of former greatness and to place a check on human vanity.

Consider a modest response to both domains. Carrier seems right about not 'necessarily' deferring to artistic intentions. Virgil wanted his epic poem *The Aeneid* destroyed and the world seems better off without the poet's intention being respected. But I suggest that artistic intentions (when known) should carry substantial weight. If Michelangelo clearly intended the Sistine ceiling to fade in color due to time, the impact of burning candles and incense, that opinion should count as a good reason (perhaps not decisive, but a good reason) not to restore it to the appearance it would have had when Michelangelo finished painting it in the mid-sixteenth century. In this way, we would respect the appearance Michelangelo had intended, though perhaps like Virgil and *The Aeneid* we would (and should) be reluctant to countenance the destruction of the artwork even if that was Michelangelo's intention (see Figure 11).

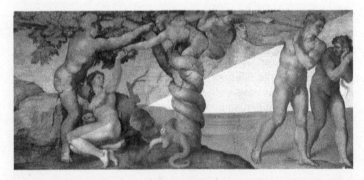

Figure 11 Michelangelo, *The Fall and Expulsion of Adam and Eve*, before (below) and after restoration (1508–12; restoration 1980–99), fresco, Sistine Chapel, Vatican (photo: Wikimedia Commons).

(As an aside, respect for artistic intention should also have some impact on debate over the colorization of black and white movies. Unless the director or producer of, say, *Casablanca*, explicitly instructed future filmmakers to colorize the film, a colorized *Casablanca* should be regarded as an appropriation rather than as an authentic or even improved version of the original film.)

As for the relocation of works of art from their original setting, museums appear to have some duty to communicate as clearly as possible the intended original setting and function of the work of art. If the icon is not observable *as an icon* but only as an abstract representation of a saint, one does not actually observe the work of art itself. Perhaps artworks are in the same situation as animals in zoos. Taken from their natural habitat, the animals may look and act quite differently than in the wild. This is why, for all that we benefit from museum institutions, they can sometimes feel like zones of quarantine, where art has been hospitalized, or like petting zoos.

Censorship

Censorship is a matter of general interest in political philosophy and any serious study of governance, but it is worthy of some attention in aesthetics. Plato himself raised the prospects of censorship in his conception of the ideal city in *The Republic*. In that dialogue, two grounds for censorship were advanced: artwork may be banned if it involves lies and falsehood, or for its imitation of evil. For Plato, there is a sense in which all theater involves lying, for it may involve someone who is not Achilles posing as Achilles and speaking as though he were Achilles. Perhaps it is the link between theater and posing as someone you are not that the word 'hypocrite' is derived from the Greek for a stage actor (*hypokrites*).

Presumably such a Platonic objection is no longer pressing. We tend today to think that many works of art constitute created

worlds and that within these worlds there are new identities. If George plays Claudius in the play *Hamlet* he is or becomes Claudius *in that Shakespearean world*. George does not thereby lie when he acts as Claudius. But many today still do share Plato's reservations about the display and promotion of what is thought to be evil. When, if ever, should the content of a work of art or its likely effect justify its public (or even private) censorship? Here are some works that are ostensibly art, but that we may wish to prohibit: films in which 'actors' are actually murdered; actual (non-simulated) rape; actual child abuse; child pornography; actual torture; bestiality and other abuses of animals; acts that seem to involve perversion such as consuming excrement, urine, or blood; artwork that tends to promote racism, violence against women, children, homosexuals, and so on. In many countries the content of films and artwork is governed by some restrictive guidelines and some of the above cases would thus involve breaking the law and would involve criminal law (for example, so-called 'snuff films' involving an actual killing are films of a murder). Still, there are at least several points to consider in terms of censorship and the philosophy of art.

First, one should bear in mind the importance of 'the test of time' in determining the meaning of a work of art. Taking the long view can help us in distinguishing between something that is wrongly or at least prematurely deemed offensive (such as Joyce's *Ulysses* which was banned at first) and works that at the time seem harmless but we may come to see as offensive. An example of the latter can be found in the Greek playwright Menander's work of New Comedy, *Epitrepontes*. In this play, Charisios marries a woman named Pamphile, who gives birth only five months after the marriage. However, it is discovered that Charisios raped a woman four months prior to his marriage, and that this same woman was in fact Pamphile, thus securing the child's legitimacy and a happy ending for all. However, such a plot is incompatible with and obscene by today's standards.

Anthony Savile offers this formulation of the test of time:

> A well-chosen . . . work of art securely survives the test of time if
> over a sufficiently long period it survives in our attention under
> an appropriate interpretation in a sufficiently embedded way.
> This condition will only be satisfied if the attention that the
> work is given is of a kind that generates experience relevant to
> its critical appreciation and attracts the attention that is given to
> it in its own right.
>
> (Savile 1982, 11–12)

Taking a long view may help stabilize the judgment over a work's
value. (Of course, to have a role in the test of time, a work needs to
be observed or read and so cannot simultaneously be uncensored.)
Still, some effort to conceive of works beyond their immediate
context seems wise.

Philosophers of art have taken up different views on pornography
and the difference (if any) between pornography and non-
pornographic erotic art. Arguments have been constructed that
pornography is either inherently bad (for example, it involves
shameful denigration, it exploits those who participate in pornog-
raphy) or instrumentally bad (for example, it tends to promote
violence against women, it supports heinous assumptions about
male supremacy or female inferiority) and counter-arguments have
been deployed that not all pornography involves inherent or
consequential harm. One rationale for identifying when a work
is pornographic versus a case of high or fine art is similar to the
rationale of when a work is a matter of mass culture or craft rather
than fine art. The typical commercial advertisement may have many
features that are akin to what is commonly recognized as fine art,
but to the extent that any such features are completely subordinate
to the goal of selling a product, one has reasons for thinking the
work is a case of mass culture and craft. Similarly, insofar as a work

(photograph, film, etc.) seems solely designed to arouse a sexual response, in which all color, design, and so on is subordinate to such an aim, it is likely that the work is not a case of erotic art, but pornographic.

Second, some art activists seem to conflate the difference between censorship and not funding the arts. In the United States, this distinction went underappreciated with the controversy over the photographs of Robert Mapplethorpe (see www.mapplethorpe.org/foundation.html). In his case, public money was not used to exhibit his work. While perhaps regrettable, this is different from censorship. In general, it seems that the case for censorship would need to be stronger than the case for not funding artwork. This is because censoring prevents the artwork from its having a hearing or viewing at all, whereas for a government or institution not to fund work does not prevent the work from finding other support.

Another point to observe concerning censorship is that your views on censorship will inevitably have to raise the question of the relation of the right and the good. Concepts of rights like the right to free speech do not explicitly enjoin that the speech must be used for what persons (the speaker and others) think of as good. Some philosophers accept a presumption of liberty principle, according to which the bare fact that an act is freely intended is a reason not to prevent it. This is only a *presumption*, for these philosophers insist that the presumption can and should be overridden in many cases. Still, if you begin with a presumption of liberty principle, censorship will always be introduced only after meeting the burden of proof. Some philosophers, on the other hand, hold that goodness is primary and rights are subordinate to what is deemed good. This theory of values tends to be more open to using the law (and hence using censorship) as an instrument of education, guiding citizens to what is deemed good.

At the end of the day, one may need to balance a perceived ideal with pragmatism. Perhaps mass industrially produced pornography (magazines, internet, etc.) is inherently degrading to consumers, producers, and the 'actors' or 'performers' involved. One may even come to believe with some evidence that such pornography indirectly fuels abusive tendencies and patterns of exploitation. Even so, if banning such pornography would only set up an aggressive, worse black market that would be even more profoundly damaging, there may be pragmatic reasons to tolerate it.

Finally, it has been argued that if a work of art should be censored on (for example) moral grounds, it makes no sense to make an exception when the work has considerable aesthetic merit. Bernard Williams writes:

> The idea of making *exceptions* to a censorship law for works with artistic merit seems, in fact, essentially confused. If one believes that censorship on certain grounds is legitimate, then if a work of artistic merit does fall under the terms of the law, it is open to censorship: its merits, indeed, may make it more dangerous, on the grounds in question, than other works. If one believes in freedom for artistic merit, then one believes in freedom, and accepts censorship only on the narrowest of ground.
>
> (Williams 1992, 68)

Williams' thesis is open to challenge. In Plato's ideal city as outlined in *The Republic*, great tragic art is censored for the young, but Plato allowed these great and valuable works to be read by the mature. Greek tragedy was thereby deemed dangerous because of its merits, too dangerous for the young but not so for those who are older and well grounded.

In wrapping up these brief observations about censorship, it is important to highlight the historically (and current) healthy and vital role that art and aesthetics can play in challenging the

status quo, pushing against the boundaries of a comfortable social order. For instance, artwork and aesthetics played a key role in the case against slavery in Britain. In censoring art, we should be cautious that we may be averting our gaze from what we need as a challenge to what can be entrenched dogmas and unexamined assumptions.

6

Cross-cultural aesthetics

Aesthetics is increasingly being practiced in cross-cultural terms. In earlier chapters there has been some reference to Indian and African aesthetics. Let us now step back and consider what is involved in taking seriously different aesthetic traditions and then look at Chinese aesthetics and Japanese aesthetics in particular. Some light can be shed on the task of cross-cultural aesthetics, if we view domains of art as worlds that we can enter. This will then allow us to highlight the virtues that are needed in cross-cultural aesthetics: these turn out to be very much like the virtues of a good explorer or traveler. Let's begin with the idea that works of art may be thought of as worlds.

Aesthetic worlds

Some works of art are denizens of our world, contemporaries as it were. Statues (such as *Venus*) and architecture can define the space and time we live in. Duchamp's *Fountain* seems more about interrupting the status quo of the artworld, rather than setting up an imaginative alternative world. But some works of art seem better described as presenting whole worlds which we may enter or leave. Compare two works of art that may be aptly described in terms of worlds. One is a modern western work that draws heavily on the pagan and Christian west, and the other one the first novel in history that draws on East Asian aesthetics.

J.R.R. Tolkien's *The Lord of the Rings* may be seen as a world, Middle Earth, which (given time and interest) we may inhabit. His world is filled with multiple languages (invented for the epic), wizards, hobbits, orcs, elves, humans, and magic. In his famous essay 'On Fairy Stories', Tolkien applauds the way narratives can constitute worlds to which we may escape. Given the popularity and epic nature of *The Lord of the Rings* (it is now translated into nearly 40 languages and in 2000 the internet retailer Amazon identified it as the book of the century), it is fitting to consider how Tolkien thought of his own work in terms of creating a world for readers to enter, thus enabling them to escape from their current circumstances:

> I have claimed that Escape is one of the main functions of fairy-stories and since I do not disapprove of them, it is plain that I do not accept the tone of scorn or pity with which 'Escape' is now so often used ... Why should a man be scorned, if, finding himself in prison, he tries to get out and go home?
>
> ... And if we leave aside for a moment 'fantasy', I do not think that the reader or the maker of fairy-stories need even be ashamed of the 'escape' of archaism: of preferring not only dragons but horses, castles, sailing ships, bows and arrows; not only elves, but knights and kings and priests.
>
> (Tolkien 2008, 375–83)

Tolkien thereby, paradoxically, depicts fairy-stories as both alternative worlds as well as an expression of our desire to overcome the barriers we face in our own world.

In reference to the values identified in Chapter 4, Tolkien's work succeeds in terms of creative imagination, and his incorporation of his own experience of warfare (he was a signal officer in the Lancashire Fusiliers in World War I), and there are abundant religious and even scientific values in play (the case can be made that Tolkien's epic supports an anti-mechanistic environmental ethic). There are narratives depicting grotesque

ugliness and awesome beauty. Tolkien worked with the theme of glory that we noted in Chapter 1, but he also paid tribute to the Platonic tradition of beauty and an appreciation for domestic goodness. After all, at the heart of *The Lord of the Rings* one finds very humble, domestic, loveable, and brave creatures: hobbits. Entering Tolkien's world means suspending your current identity and place and taking in his wondrous, dangerous, and bittersweet landscapes and characters.

Entering the world of Tolkien's epic fairy-tale requires a suspension of disbelief in magic and an openness to the terms Tolkien sets for us: the fates of men and women, elves, orcs, hobbits, dwarves, and so on, all depend on what is done with a powerful ring.

Consider now *The Tale of Genji*, believed to be by Murasaki Shikibu, a late tenth-century or early eleventh-century member of the Heian Court in Japan. The story is about Genji, son of the emperor but who has to live as a commoner due to the jealousy of the emperor's first wife. Unlike Aragorn or Gandalf of *The Lord of the Rings*, Shikibu's main character is not a warrior or wizard; his skills are in artistic creativity. He is adept at poetry, fashion, and painting. He experiences a series of romantic (or at least sexual) relationships, and he must contend with jealousy among his wives; he fathers a future emperor (his daughter) and thereby becomes the grandfather of another emperor. Running throughout the novel is Genji's possession of *mono no aware* (which in this case may be understood to be a general sensitivity to things). There is a sadness and beauty to the story in which a dramatic quest (the search for a perfect mate) invites reflection on the futility of desire. There is a rich, distinctive Asian aesthetic to the work as a whole, with its weaving in of poetry (there are nearly 800 poems in the novel), narrative drama, and a philosophy of desire that borders on (but may not be necessarily) Buddhist aesthetics. To enter into the novel is to make a start in entering the world of Japanese aesthetics.

To enter a work of art as if it were a world requires certain virtues: attentiveness, patience, sensitivity, the exercise of ethical or moral values. It especially requires setting aside our own narcissistic tendencies. We can fuel our self-preoccupation by identifying with this or that character. But entering into the worlds of some works of art requires an openness both to seeing and feeling one's way in and around characters and drama. Works of art can comprise whole worlds without narratives or with very subtle narratives, such as a Chinese landscape (Figure 12) or Rublev's *The Trinity* (Figure 4).

Seeing some works of art as comprising whole worlds partly explains the emotions we feel when we weep over the death of a fictitious character in theater, film, poetry, opera, and literature. We have such emotions because those emotions are fitting in the world that the work of art creates or projects.

A lesson for cultural aesthetics from the aesthetics of natural environments: today there is increasing attention to the different ways of aesthetically appreciating nature. Allen Carlson has usefully distinguished four models for the appreciation of nature: the object, landscape, engagement, and natural environmental models. The object model will extract an object (a stone, for example) and appreciate its aesthetic features in a way that is quite independent of the environment it came from. The landscape model looks at the natural world from a distance and with a viewpoint that tends to be fixed by conventional drawing, painting, and photography. The engagement model involves sensory immersion into one's interplay in the natural world with no conceptual concerns about ecology and the like. The environmental model is guided by ecology. On this view, the appreciation of a desert will be different from a mountain range, a river valley, a deciduous forest, and so on. The appreciation is different because the ecology is different. So, a desert is not a bad river valley; rather, it needs to be seen and assessed or appreciated on its own terms. Similarly the appreciation of Chinese landscape

painting needs to be appreciated on its own terms and not from the standpoint of American landscape painting in the nineteenth century for example. This need to appreciate works of art on their own terms is as important for cross-cultural aesthetics as it is for assessing works of art in different genres in the same culture. The history of painting and photography provides evidence for the need to assess artwork on its own terms. With the advent of the camera, some photographers thought they needed their photographs to look like paintings in order to be considered fine art. Soon matters changed and some painters thought they needed to make their paintings look like photographs to have credibility. Fortunately the competition seems to have died down and there is now a great passion for artwork with mixed media.

Let's briefly consider the world of Chinese aesthetics and then Japanese aesthetics, and then return to the theme of how a cross-cultural aesthetic expedition is like travel, and therefore involves the virtue of a good traveler. Part of the point behind the descriptions of the Chinese and Japanese background that follow is that art and aesthetics must be viewed in context with a sensitive awareness of how that context differs from your own, more familiar setting.

Chinese aesthetics

In an investigation of Chinese aesthetics, one needs to appreciate the broad cultural context of art. The arts in China have historically played an important role in ritual and governance and have been influenced by Confucian, Buddhist, and Taoist traditions. Music, poetry and literature, ceramics, textiles, and the pictorial arts have had a long history of respect and practice. The respect has also included a certain wariness that we saw earlier with Plato: Confucius was aware of the positive power good art (especially music and literature) could have in education, but he

was also concerned about how music and the other arts can be used badly. The legendary founder of Daoism, Laozi, also worried about how the arts can distract us from following the Tao or the Way (essentially the path of wise, natural living). Running through each of the genres of art is a philosophy of balance in which one element (yang) would be seen in relation to another element (yin). Rather than the deep dualistic juxtapositions of good and evil as found in traditional monotheism, yin and yang are seen as related and interdependent (male and female, light and dark, active and passive).

Aesthetic practices are historically deeply embedded in culture. In official Confucianism, that system that was enforced by the civil service examination system, literature in general but especially poetry was highly prized. Literature was thought to convey moral content – there was a notion that literature transmits the Way (*wenyi zai dao* – 文艺载道 – here the Way is a Confucian moral order rather than the Taoist Way). Poetry was considered a means of *zhiren* – understanding humanity. One of the texts included in the Confucian canon was the *Book of Songs* (*Shijing*), an anthology of 305 poems that may have been compiled by Confucius. As part of the civil service examination, candidates had to write essays on the *Book of Songs* and compose poetry on a set theme with a set rhyme – so every official, from district magistrate to ministers in the central government, was a poet. The traditional civil service examination system was abolished in 1905, but anyone with a classical education was expected to be able to write poetry. Both Mao Zedong and Ho Chi Minh (who had a classical Chinese education in Vietnam) wrote classical Chinese poetry.

Sadly, Chinese aesthetics and the arts seemed to suffer under Mao. Mao regarded art and literature mainly as tools for revolution, but attacked art and literature that he regarded as feudal, reactionary, counter-revolutionary, and so forth. The Cultural Revolution was officially the Great Proletarian Cultural

Revolution, meant to create a proletarian revolutionary culture to replace classical ('feudal') and foreign-influenced ('imperialist') culture. A quarter-century earlier, Mao gave his talks at the Yan'an Forum on Art and Literature, where he insisted on the political nature of culture. Under Mao, the arts were largely assessed on the grounds of political ideology rather than in light of beauty, imagination, and so on.

Consider briefly two elements in Chinese aesthetics: the imagination and the aesthetic implications of the place of humans in the natural world.

One of the most highly regarded texts in Chinese aesthetics is the *Wenxin diaolong* (*The Literary Mind and the Carving of Dragons*) by Liu Xie (465–523) in which it is said that good writing and wise living are interrelated. Thus, the art of literature has a bearing on sagehood. In the second half of his masterpiece, Liu Xie mixes together specific observations about craft, medicine, and ornamentation with reflection on beauty, timeliness, objectivity, and the imagination. A central artistic power lies in the fruitful use of imagination, which Liu Xie refers to as spiritual or spirited thought. Through imagination the artist is able to draw on past events, memories, and languages. Liu Xie introduces this couplet to introduce the imagination:

The ancients said, 'One's form may be at sea, while one's mind resides under the towers of Wei.' This is speaking about 'spiritual thought'. Literary thought is of far-ranging spirit.

(Liu Xie 1995, 71)

For Liu Xie the best use of imagination in literary work (and by extension the other arts) consists in a balance of inner thought and emotion and external action, mind and matter, images and objects. In some respects Liu Xie's work on the imagination pre-dated the west's positive stance regarding the imagination that came into play in early modern philosophy

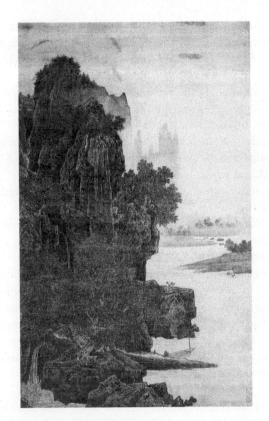

Figure 12 Hsiao Chao, *Pavilions on a Mountainside* (c. twelfth century), hanging scroll, ink on silk.

(and reached its zenith with the British romantic poets such as Wordsworth).

As for humans and nature, artwork influenced by Taoism, as well as Buddhism, tended to portray human beings in humble terms, very small in the landscape, often turned away from the viewer and dwarfed against a backdrop of large mountains. The theme that is often suggested is the passage of time and the transitory nature of human life. The tone of such work seems

nonviolent, substituting a humble meditative contemplation for self-aggrandizement and the vain pursuit of glory. The Taoist aesthetic (in music and the visual arts) seeks to orient us to wise individual action as opposed to corporate discipline (though Taoist texts do offer sage advice on how to successfully wage war). Artwork inspired by Taoism shares Plato's cultivation of the love of beauty rather than glory, but it does not promote Diotima's ladder of love that reaches to a transcendent pure beauty. Beauty is, rather, to be found in the natural world.

In Chapter 2 on 'What is art?', we noted how some theories of art highlight the way in which artwork is intentionally made for contemplation. In Chinese and Japanese aesthetics there is an especially interesting way in which some art is framed and identified for contemplation: through calligraphy. One can identify poems in Chinese and Japanese not just by the content or meaning of the language, but also by the way the ideograms are written. The closest we have to this practice in the west is the use of illumination of texts in the medieval era, but unlike calligraphy such illuminations would be limited to the first letter of a Gospel or as decorative figures or aids to religious reading and reflection. In Chinese and Japanese calligraphy, whole phrases and texts would be written out and the teachers, scholars, poets, and artists who practiced calligraphy would earn reputations for their hand and distinctive style. One of the most beloved Japanese calligraphers was Kūkai (774–835, also known as Kōbō-Daishi), a Buddhist monk who studied calligraphy in China and raised the standard of calligraphy in Japan.

Aesthetics in Japan

While it is true that the word in Japanese for 'aesthetics' (*bigaku*) was coined only very recently, in the late nineteenth century during the Meiji Restoration, as Japanese thinkers came in contact with western aesthetic theories (Junko 2001, 29–30), a long history of discussions about the arts does exist. Granting that

aesthetic tastes and values change over the expanse of Japanese history, one can still point to several elements as the sources of aesthetics in Japanese culture: Shinto and Buddhist teachings about purity, sincerity, and impermanence, and the role of nature itself. Being open to Japanese aesthetics therefore requires a greater openness to religious values, especially the value of sincerity (*magokoro*), than one finds in the western secular sectors of the artworld.

Purity is closely tied to Japan's indigenous religion of Shinto ('the way of the gods'). Shinto is a collection of religious practices and motifs that includes reverence for nature and an emphasis on purification (the cleansing away of pollution). Impermanence is an important Buddhist religious theme since Buddhism denies the existence of permanent essences. Nature plays a unifying role with these other sources since natural elements (waterfalls, the sea) are purifying agents, and Shinto deities are most often nature deities. Furthermore, many natural elements and processes are vivid indicators of the Buddhist theme of the impermanence that marks our lives – cherry blossoms with their achievement of beauty even as they fall are the preeminent example. The point here is that cherry blossoms are not only aesthetically pleasing because they are beautiful as blossoms but because of the pathos of being tragically but beautifully impermanent, falling not long after they achieve their first beauty, that of their blossoming.

These ideas suggest that the religious is bound up with the aesthetic in Japanese aesthetics, and indeed, many writers on Japanese aesthetics indicate that the categories are not sharply differentiated in Japan. Hence, one can speak of the 'religio-aesthetic'. One of the greatest of Japanese poets, Saigyō (1118–90), spent much of his life following the ideal of a religious/aesthetic recluse and his poems often display both aspects:

He who casts himself away –
has he truly

cast himself away?
The real castaway is one
who casts nothing away at all!

(Watson 1991, 219)

(On Mt Fuji, written while carrying out religious practice in the
 eastern provinces)
Trailing on the wind,
the smoke of Mount Fuji
fades in the sky,
moving like my thoughts
toward some unknown end

(Watson 1991, 210)

But this can be further complicated when the theme of purity
or purification is included within the aesthetic. While purity
contains aspects which lean towards truth, other aspects of
purity are clearly ethical. One of the most fundamental aesthetic
values in Japan is *makoto* (sincerity, genuineness, true-heartedness,
integrity). This means that the ethical sphere is also melded with
the religious and the aesthetic. While in the west, when sincerity
is held to be a virtue, it is often thought of as a very thin virtue,
not a fundamental virtue. Indeed, in one usage, we can speak of
someone who lacks many other good-making qualities, by saying
'at least she/he is sincere'. In almost an exactly opposite way,
makoto is held to be the foundation of other aesthetically good-
making qualities. Consider some of these statements taken from
Japanese writing about poetics. Hisamatsu Sen'ichi, referencing
the Makoto-ben of Fujitani Mitsue (1738–79), states:

> Speaking in Mitsue's terms, we may say that *makoto*, a natural
> union of emotion, reason, and will, is the essential human quality,
> and that the same quality underlies all literature.

(Hisamatsu 1963, 11)

And in the words of the haiku (haikai) master Onitsura (a contemporary of Bashō (1644–94)):

Outside of makoto there is no haikai.

<div align="right">(Onitsura 1978, 194)</div>

Consider the following poems by Onitsura, which some say strongly exemplifies *makoto*:

In front of the garden
It has whitely blossomed –
The camellia.

The blossoms scatter
And it is tranquil again:
Onjōji.

<div align="right">(Keene 1976, 65–6)</div>

In what sense is true-heartedness exemplified here? Of course in one sense, Onitsura is stating a simple truth about what he sees in the natural world; at least in that sense there is no duplicity, and hence there is a kind of sincerity, a purity in expression. But then does any simple statement of a perception about nature count as possessing *makoto*, a fundamental aesthetic quality? How does this make for good poetry?

To deepen our inquiry and to extend our understanding of *makoto*, consider these words of Bashō, perhaps the most famous haiku poet, in his poetry and prose travel diary *The Records of a Travel-worn Satchel* (*Oi no kobumi*):

Saigyō in traditional poetry, Sōgi in linked verse, Sesshū in painting, Rikyū in tea ceremony, and indeed all who have achieved real excellence in any art, possess one thing in common, that is, a mind to obey nature, to be one with nature, throughout the four seasons of the year. Whatever such a mind sees is a

flower, and whatever such a mind dreams of is the moon. It is only a barbarous mind that sees other than the flower, merely an animal mind that dreams of other than the moon. The first lesson for the artist is, therefore, to learn how to overcome such barbarism and animality, to follow nature, to be one with nature.

(Bashō, in Yuasa 1966, 71–2)

'Flower' and 'moon' are often used to stand for deepened insight into reality. The way in which such insights are realized, however, is what is important here; one who wants to be an artist must learn to be one with, to follow, nature, not just to follow one's own self. *Makoto* as an aesthetic ground does not just refer to personal sincerity on the part of the artist/poet. It has an ontological status since it is derived from both 'true word' and 'true thing/deed' (Hisamatsu 1963, 10). Here the poet achieves *makoto* as a personal state in part following the true nature of the natural object. Bashō's ideas here are recorded in the *Sanzōshi*:

There is the Master's saying: 'Of the pine-tree learn from the pine-tree. Of the bamboo learn from the bamboo.' By this the Master meant that one should free oneself from subjective arbitrariness. There are those who indulge in interpreting freely in their own manner what is meant by the world 'learn', resulting in 'not-learning' after all. To 'learn' means here to have the (existential) experience in which a poet first penetrates into, and identifies himself with, a thing, and in which as the 'first and faintest stir of the inner reality' (bi) emerges from the thing, it activates the creative emotion of the poet (as an instantaneous sensation), which becomes crystallized on the spot into a poetic expression.

(Bashō, cited in Izutsu and Izutsu 1981, 162–3)

Spontaneity of creative act is highly prized in the Japanese aesthetic tradition, as in the arts of *sumi* ink painting and

calligraphy, for example. This is due in part to the underlying sense of learning from nature, or becoming one with nature. Hence, it is out of that state that the work of art arises. Makoto Ueda, a contemporary commentator on Bashō, notes:

> A good poet does not 'make' a poem; he keeps contemplating his subject until it 'becomes' a poem. A poem forms itself spontaneously. If the poet labors to compose a poem out of his own self, it will impair the 'soul' of his subject. He should enter into the external object (the subject of his poem), instead of forcing it to come to him.
>
> (Ueda 1982, 168)

A very strong sense of this mutuality of poet and natural subject of the poem is highlighted by Shinken (1649–1712) when describing Bashō's work:

> While reading our Old Master's essay on the Unreal Hermitage, I realized that he possesses the soul of reclusion and that in his writing the scenery has found a person to know it rightly. So it is that this person and the natural scene have taken on full existence in their mutual relation.
>
> (Shinken, in Miner and Ogadiri 1981, 313)

It is out of this mutuality that the spontaneous creative act occurs.

Spontaneous creation is adduced as a kind of evidence that the proper preparation and grounding has been achieved by the artist.

The twentieth-century novelist and Nobel Laureate Kawabata Yasunari makes a similar point in his acceptance speech, 'Japan, the Beautiful, and Myself'. There he begins with two poems (and the speech as a whole is a rich treasury of poetic and literary references and commentary):

In the spring, cherry blossoms,
in the summer the cuckoo.
In autumn the moon, and in
winter the snow, clear, cold. [Dōgen]

Winter moon, coming from the
Clouds to keep me company,
Is the wind piercing, the snow cold? [Myōe]

Kawabata comments particularly on the spontaneity of Myōe's poems about the moon:

Seeing the moon, he becomes the moon, the moon seen by him becomes him. He sinks into nature, becomes one with nature. The light of the 'clear heart' of the priest, seated in the meditation hall in the darkness before the dawn, becomes for the dawn moon its own light.

(Kawabata 1968, 71–70)

But there is much more to Japanese aesthetics than *makoto* and the interplay between the aesthetic and the religious and the ethical. *Mono no aware* (sometimes translated as the 'pathos of things') is related to the earlier discussion of seeing the true nature of things in the world, but it adds an emotional element in terms of the observer's response to that which is in the world (' ... [it] suggest[s] the pathos inherent in the beauty of the outer world, a beauty that is inexorably fated to disappear together with the observer. Buddhist doctrines about the evanescence of all living things naturally influenced this particular content of the work, but the stress in *aware* was always on direct emotional experience rather than on religious understanding' (Morris 1994, 196–7)).

This emphasis on emotional response is also evident in the Japanese interest in the unique or the unusual in natural objects

(sometimes associated with the divine in Shinto). Imperfection, irregularity, or asymmetry in a work of art is also usually an important aesthetic quality. One fine example of this emphasis on irregularity is in the value placed on irregularly shaped tea bowls for use in the Tea Ceremony.

In this all too brief overview one can see a rich aesthetic world in which *makoto* is prized, impermanence is taken seriously in art and the experience of nature, and other values.

In order to travel to different domains of works of art, some of the virtues of the traveler or explorer are called for: openness, patience, kindness, receptivity to assistance from strangers. Without such openness, you would miss the vital role of *makoto* in Japanese aesthetics and the philosophy behind the depiction of humans in nature in Chinese landscape painting and drawing. Different metaphors for artworks may invite different virtues, but this *Beginner's Guide* now needs to end. Some might prefer to think of artworks as vehicles to drive well or badly, or as food to digest well or not so well. But insofar as you do see them as worlds, the skills of a traveler or explorer seem promising. I therefore end this book with the classic last lines of Charles Darwin's *The Voyage of the Beagle*, in which he commends travel for naturalists, though in this case I cite it as a commendation to you, as lovers of works of art and the beautiful:

> But I have too deeply enjoyed the voyage, not to recommend any naturalist, although he must not expect to be so fortunate in his companions as I have been, to take all chances, and to start, on travels by land if possible, if otherwise on a long voyage. He may feel assured, he will meet with no difficulties or dangers, excepting in rare cases, nearly so bad as he beforehand anticipates. In a moral point of view, the effect ought to be to teach him good-humoured patience, freedom from selfishness, the habit of acting for himself, and of making the best of every occurrence. In short, he ought to partake of the characteristic qualities of

most sailors. Travelling ought also to teach him distrust; but at the same time he will discover, how many truly kind-hearted people there are, with whom he never before had, or ever again will have any further communication, who yet are ready to offer him the most disinterested assistance.

(Darwin 1909, 533)

Further resources and reading

International aesthetic organizations

American Society for Aesthetics: http://www.aesthetics-online.org/

British Society for Aesthetics: http://www.british-aesthetics.org/

Canadian Society for Aesthetics: http://www.csa-sce.ca/

Centre for Cognitive Issues in the Arts: http://www.bristol.ac.uk/philosophy/#CCIA

CEPHAD (Centre for Philosophy and Design): http://www.dkds.dk/forskning/projekter/cephad

Dutch Association of Aesthetics: http://www.nge.nl/

European Society for Aesthetics: http://www.eurosa.org/

The International Association for Philosophy and Literature: http://www.stonybrook.edu/iapl/index.html

The International Association of Empirical Aesthetics (IAEA): http://www.science-of-aesthetics.org/

International Institute of Applied Aesthetics: http://www.helsinki.fi/jarj/iiaa/engindex

Plasticités Sciences Arts: http://plasticites-sciences-arts.org/

Society for Music and Aesthetics: http://www.musik-und-aesthetik.de/

Sydney Society of Literature and Aesthetics: http://www.ssla.soc.usyd.edu.au/

Aesthetics journals

British Journal of Aesthetics
Contemporary Aesthetics
Journal of Aesthetics and Art Criticism
Journal of Aesthetic Education
Journal of Aesthetics and Culture

Additional reading on beauty

Mothersill, M. (1984) *Beauty Restored*. Oxford: Oxford University Press.

Murdoch, Iris (1970) *The Sovereignty of Good*. New York: Routledge, 2007.

Scarry, Elaine (1999) *On Beauty and Being Just*. Princeton, NJ: Princeton University Press.

Sircello, Guy (1975) *A New Theory of Beauty*. Princeton Essays on the Arts, 1. Princeton, NJ: Princeton University Press.

Sircello, Guy (1978) *Mind & Art: An Essay on the Varieties of Expression*. Princeton Paperbacks. Princeton, NJ: Princeton University Press, 1978.

Sircello, Guy (1989) *Love and Beauty*. Princeton, NJ: Princeton University Press.

Recommended aesthetic readings from a multi-cultural perspective

Coomaraswamy, Ananda Kentisy (1969) *Introduction to Indian Art*. 2nd edn. Delhi: Munshiram Manoharlal.

Crowley, Daniel J. (1966) An African Aesthetic. *Journal of Aesthetics and Art Criticism* 24: 519–24.

Fuguan, Xu (1986) *The Chinese Aesthetic Spirit*. Taipei: Students.

Herman, A.L. (1965) Indian Art and Levels of Meaning. *Philosophy East and West* 15: 13–30.

Lawal, Babatunde (1974) Some Aspects of Yoruba Aesthetics. *British Journal of Aesthetics* 14: 239–49.

Onyewuenyi, Innocent C. (1984) Traditional African Aesthetics: A Philosophical Perspective. *International Philosophical Quarterly* 24: 237–44.

Raffé, W.G. (1952) Ragas and Raginis: A Key to Hindu Aesthetics. *Journal of Aesthetics and Art Criticism* 11: 105–17.

Tsunoda, Ryusaku, William Theodore de Bary, and Donald Keene (1958) *Sources of Japanese Traditions*. New York: Columbia University Press.

Ueda, Makoto (1967) *Literary and Art Theories in Japan*. Cleveland: Press of Western Reserve University.

Yutang, Lin (1967) *The Chinese Theory of Art*. New York: Putnam's.

Bibliography

Aristotle (1984) Poetics. In *The Complete Works of Aristotle: The Revised Oxford Translation*, ed. J. Barnes. Princeton, NJ: Princeton University Press.

Arnheim, Rudolf (1974) *Art and Visual Perception: A Psychology of the Creative Eye*. New, expanded and rev. edn. Berkeley: University of California Press.

Balzac, Honoré de (1916) *The Analysis of Art*. New Haven: Yale University Press.

Barthes, Roland (1974) *S/Z*, trans. R. Miller. New York: Hill and Wang.

Barthes, Roland (1979) From Work to Text. In *Textual Strategies*, ed. J. V. Harari. Ithaca: Cornell University Press.

Beardsley, M. (1958) *Aesthetics*. New York: Harcourt Brace.

Beardsley, M. (1982) *The Aesthetic Point of View*, ed. M. Wreen. Ithaca: Cornell University Press.

Bell, C. (1958) *Art*. New York: Capricorn Books.

Binkley, T. (1987) Piece: Contra Aesthetics. In *Philosophy Looks at the Arts*, ed. J. Margolis, 3rd edn. Philadelphia: Temple University Press.

Binkley, T. (1996) Piece: Contra Aesthetics. In *Aesthetics in Perspective*, ed. Kathleen Higgins. New York: Harcourt Brace.

Bullough, Edward (1912) 'Physical Distance' as a Factor in Art and an Aesthetic Principle. *British Journal of Psychology*, 5: 87–117.

Burke, Edmund (1856) *A Philosophical Inquiry into the Origin of Our Ideas of the Sublime and Beautiful with an Introductory Discourse Concerning Taste*. New York: Harper & Brothers.

Burkholder, Peter (2005) *Norton Anthology of Western Music*. New York: W.W. Norton & Co.

Cage, John (1961) *Silence: Lectures and Writings*. Middletown: Wesleyan.

Carrier, David (2009) Conservation and Restoration. In *A Companion to Aesthetics*, ed. S. Davies. Malden, MA: Wiley-Blackwell.

Carroll, N. (2001) *Beyond Aesthetics*. Cambridge: Cambridge University Press.

Chesterton, G.K. (1909) *Charles Dickens: A Critical Study*. New York: Dodd Mead & Company.

Collingwood, R.G. (1938) *Principles of Art*. Oxford: Clarendon Press.

Coomaraswamy, A. (2005) *Buddhist Art*. Whitefish, MT: Kessinger Publishing.

Danto, A. (1964) The Artworld. *Journal of Philosophy*, 571–84.

Danto, A. (1981) *The Transfiguration of the Commonplace: A Philosophy of Art*. New York: Columbia University Press.

Darwin, Charles (1909) *The Voyage of the Beagle*. New York: P.F. Collier & Son.

Devereaux, M. (2003) The New Aesthetics. In *Arguing about Art*, ed. A. Neil and A. Ridley. London: Routledge.

Dewey, John (1934) *Art as Experience*. New York: Perigee Trade.

Dewey, John (1996) Aesthetic Qualities. In *Aesthetics in Perspective*, ed. K. M. Higgins. Wadsworth: Thomson Learning.

Dickie, George (1974) *Art and the Aesthetic: An Institutional Analysis*. Ithaca, NY: Cornell University Press.

Dickie, George (2004) Defining Art: Intension and Extension. In *The Blackwell Guide to Aesthetics*, ed. P. Kivy. Malden, MA: Blackwell.

Eliot, T.S. (1998) *The Wasteland and Other Poems*. New York: New American Library.

Frankfurt, Harry G. (2004) *The Reasons of Love*. Princeton, NJ: Princeton University Press.

Gaut, B. (2003) When is Art? In *Arguing about Art*, ed. A. Neil and A. Ridley. London: Routledge.

Gaut, B. (2008) The Ethical Criticism of Art. In *Aesthetics: A Comprehensive Anthology*, ed. S. Cahn and A. Meskin. Oxford: Blackwell.

Gombrich, E.H. (1960) *Art and Illusion*. Princeton, NJ: Princeton University Press.

Goodman, N. (2008) When is Art? In *Aesthetics*, ed. S. Cahn and A. Meskin. Oxford: Blackwell.

Goswami, B.N. (1996) Rasa: Delight of the Reason. In *Aesthetics in Perspective*, ed. K.M. Higgins. Wadsworth: Thomson Learning.

Gupta, K.S. (1996) Indian Aesthetics. In *A Companion to Aesthetics*, ed. Robert Hopkins and Crispin Sartwell. Chichester: John Wiley & Sons.

Hartshorne, Charles (1968) *The Philosophy and Psychology of Sensation*. Port Washington, NY: Kennikat Press.

Hegel, G.W.F. (1975) *Aesthetics: Lectures on Fine Art*, trans. T.M. Knox. Oxford: Oxford University Press.

Hisamatsu, Sen'ichi (1963) *The Vocabulary of Japanese Literary Aesthetics*. Tokyo: Center for East Asian Studies.

Homer (1867) *Iliad: Tr. into English*, trans. J. I. Cochrane. Harvard University.

Hume, D. (1965) Of the Standard of Taste. In *Of the Standard of Taste and Other Essays*, ed. J. Lenz. New York: Bobbs-Merrill.

Iseminger, Gary (2004) *The Aesthetic Function of Art*. Ithaca, NY: Cornell University Press.

Iversen, M. (1988) Saussure Versus Peirce: Models for a Semiotics of Visual Arts. In *The New Art History*, ed. A. L. Rees and F. Barzello. Atlantic Highland, NJ: Humanities Press.

Izutsu, Toshihiko and Toyo (1981) *The Theory of Beauty in the Classical Aesthetics of Japan.* Dordrecht: Kluwer.

Janaway, Christopher (2001) Plato. In *The Routledge Companion to Aesthetics*, ed. B. Gaut and Dominic McIver Lopez. New York: Routledge.

Junko, Saeki (2001) Longing for beauty. In *A History of Modern Japanese*, ed. Michael F. Marra. Honolulu: University of Hawaii Press.

Kant, I. (1964) *Critique of Judgement*, trans. J. Meredith. Oxford: Clarendon Press.

Kant, I. (1982) *The Critique of Judgement*, trans. J.C. Meredith. Oxford: Clarendon Press.

Kawabata, Yasunari (1968) *Japan the Beautiful and Myself: The 1968 Nobel Prize Acceptance Speech*, trans. E. G. Seidensticker. Tokyo: Kodansha International.

Keene, Donald (1976) *World Within Walls.* New York: Holt, Rinehart and Winston.

Knox, Ronald (1920) *Patrick Shaw-Stewart.* Glasgow: William Collins Sons and Co.

Langer, S. (1942) *Philosophy in a New Key: A Study in the Symbolism of Reason, Rite and Art.* 3rd edn. Cambridge, MA: Harvard University Press.

Langer, S. (1953) *Feeling and Form.* New York: Scribner's.

Lauter, E. (1993) Re-Enfranchising Art. In *Aesthetics in Feminist Perspective*, ed. H. Hein and C. Korsmeyer. Bloomington: Indiana University Press.

Levinson, Jerrold (1980) What a Musical Work Is. *Journal of Philosophy* 77 (1): 5–28.

Lewis, C.S. (1992) *An Experiment in Criticism.* Canto edn. Cambridge and New York: Cambridge University Press.

Lewis, C.S. (2006) *An Experiment in Criticism.* Cambridge: Cambridge University Press.

Lyas, C. (1997) *Aesthetics.* Montréal: McGill-Queens Press.

Malraux, André (1974) *La téte d'obsidienne.* Gallimard: Paris.

Miner, Earl, and Hiroko Odagiri (trans.) (1981) *The Monkey's Straw Raincoat and Other Poetry of the Bashō School*. Princeton, NJ: Princeton University Press.

Mitchell, W.J.T. (2006) *What Do Pictures Want?* Chicago: University of Chicago Press.

Morris, Ivan (1994) *The World of the Shining Prince: Court Life in Ancient Japan*. Tokyo: Kodansha. Original edn. 1964.

Murdoch, Iris (1992) *Metaphysics as a Guide to Morals*. London: Chatto & Windus.

Murdoch, Iris (2007) *The Sovereignty of Good*. New York: Routledge. Original edn. 1970.

Onitsura (1978) Hitorigoto. In *Onitsura Zenshū*, ed. O. Rihei. Tokyo: Kadokawa Shoten.

Osborne, Harold (1970) *Aesthetics and Art Theory: A Historical Introduction*. New York: Dutton.

Parker, DeWitt H. (1916) *The Analysis of Art*. New Haven: Yale University Press.

Plato (1983) Ion. In *Two Comic Dialogues: Ion and Hippias Major*. Indianapolis, IN, and Cambridge, MA: Hackett Publishing.

Plato (1989) Symposium. In *Symposium*. Indianapolis, IN, and Cambridge, MA: Hackett Publishing.

Plato (1994) Symposium. In *The Collected Dialogues of Plato Including the Letters*, ed. E. Hamilton and H. Cairns. Princeton, NJ: Princeton University Press.

Plato (1994) The Republic. In *The Collected Dialogues of Plato Including the Letters*, edited by E. Hamilton and H. Cairns. Princeton, NJ: Princeton University Press.

Plato (2001) Images of Excellence. In *Plato's Critique of the Arts*. Oxford: Oxford University Press.

Richards, I.A. (1964) *Practical Criticism*. London: Routledge.

Ross, S.D. (1998) Beauty. In *Encyclopedia of Aesthetics*, 4 vols. New York: Oxford University Press.

Ross, W.D. (1930) *The Right and the Good*. Oxford: Clarendon Press.

Savile, A. (1982) *The Test of Time: An Essay in Philosophical Aesthetics*. Oxford: Clarendon Press.

Schiller, Friedrich, Elizabeth M. Wilkinson, and L. A. Willoughby (1982) *On the Aesthetic Education of Man, in a Series of Letters*. Oxford and New York: Clarendon Press, Oxford University Press.

Shapiro, Daniel (1998) Law and Art: Cultural Property. In *Encyclopedia of Aesthetics*, ed. M. Kelly. New York: Oxford University Press.

Sircello, Guy (1989) *Love and Beauty*. Princeton, NJ: Princeton University Press.

Sorabji, Richard (2000) *Emotion and Peace of Mind: From Stoic Agitation to Christian Temptation, The Gifford Lectures*. Oxford and New York: Oxford University Press.

Taliaferro, Charles (1990) The Ideal Aesthetic Observer. *British Journal of Aesthetics* 30 (1): 1–13.

Taliaferro, C. and J. Evans (2011) *The Image in Mind*. London: Continuum.

Tanner, M. (2003) Morals in Fiction and Fictional Morality – A Response. In *Arguing about Art*, ed. A. Neil and A. Ridley. London: Routledge.

Tolkien, J.R.R. (2008) On Fairy Stories. In *Tales From the Perilous Realm*. New York: Houghton Mifflin.

Tolstoy, L. (1960) *What is Art?* Indianapolis: Bobbs-Merrill.

Ueda, Makoto (1982) *Matsuo Bashō*. Tokyo: Kodansha.

Vasari, G. (1978) *Lives of the Artists*, trans. G. Bull. London: Allen Lane.

Wallmark, Zach (2010) More on Borrowing. *The Taruskin Challenge*. taruskinchallenge.wordpress.com/2010/03/16/more-on-borrowing/.

Walton, K. (2003) Morals in Fiction and Fictional Morality. In *Arguing About Art*, ed. A. Neil and A. Ridley. London: Routledge.

Walton, K. (2005) Transparent Pictures. In *Aesthetics*, ed. D. Goldblatt and L.B. Brown. Upper Saddle River, NJ: Prentice Hall.

Watson, Burton (trans.) (1991) *Saigyō: Poems of a Mountain Home*. New York: Columbia University Press.

Weil, S. (1941) The Iliad or the Poem of Force. In *Simone Weil: An Anthology*, ed. S. Miles. New York: Weidenfeld and Nicolson.

Weiss, P. and Taruskin, R. (2007) *Music in the Western World*. Florence: Cengage Learning.

Weitz, M. (1950) *Philosophy of the Arts*. Cambridge, MA: Harvard University Press.

Williams, Bernard (1992) Censorship. In *A Companion to Aesthetics*, ed. D.E. Cooper. Oxford: Blackwell.

Wimsatt, W.K. Jr and Monroe Beardsley (2008) The Intentional Fallacy. In *Aesthetics: A Comprehensive Anthology*, ed. S. M. Cahn and A. Meskin. Oxford: Blackwell Publishing Ltd.

Xie, Liu (1995) *Chinese Aesthetics, A Companion to Aesthetics*. Oxford: Blackwell Publishers Ltd.

Young, J.O. (2003) The Concept of Authentic Performance. In *Arguing about Art*, ed. A. Neil and A. Ridley. London: Routledge.

Yuasa, Nobuyuki (1966) *Bashō: The Narrow Road to the Deep North and Other Travel Sketches*. Baltimore: Penguin Books.

Zemach, Eddy M. (1995) Truth in Art. In *A Companion to Aesthetics*, ed. D.E. Cooper. Oxford: Blackwell.

Index